Anywhere, Anytime Art

CRAYON

AN ARTIST'S COLORFUL GUIDE TO DRAWING ON THE GO!

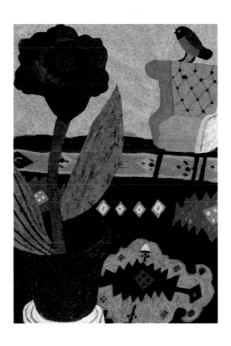

Monika Forsberg

Quarto is the authority on a wide range of topics.
Quarto educates, entertains, and enriches the lives of our readers—
enthusiasts and lovers of hands-on living.
www.quartoknows.com

6 Orchard Road, Suite 100
Lake Forest, CA 92630
quartoknows.com
Visit our blogs at quartoknows.com

Printed in China

3 5 7 9 10 8 6 4 2

MIX
Paper from
responsible sources
FSC® C104723

TABLE of CONTENTS

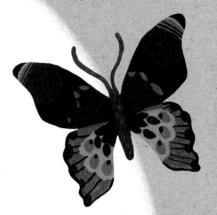

INTRODUCTION

Hi, my name is Monika! I am a London-based illustrator. Most of the work I do is on commission, which means I have an assignment. Believe it or not, when you work within a framework of "restrictions," the process can be easier. You can bend and alter things within these restrictions, and sometimes you'll come up with unique concepts. When you have no constraints, you can't ask yourself, "How do I do this?" Instead, you have a sea of possibilities without much direction.

When you have the whole world (as well as your inner make-believe world) to sketch and draw, it is easy to feel lost, discouraged, or intimidated. That is why this book is full of fun little projects with step-by-step instructions. Breaking projects into manageable chunks makes the creative process less daunting.

Here's how to get started: Set aside a little bit of time every day to draw. Many people find it helpful to have a routine that helps them get into the habit of drawing. Build habits around your creative process.

If you haven't drawn since you were young, you might be out of practice. Train for it. Draw (a lot!), and get your engine warmed up before you start making demands of yourself. Find a way to work that suits you. Once you're rolling, you can start looking at your work with an open mind and make other goals and changes.

Keep an art journal, and post it to a blog or on social media. By posting your work online, you will get encouragement and comments, and you will establish a timeline of your creative process and progress to look back on.

My personal routine and drawing habits go like this: Once my two kids have gone off to school, I skip downstairs to my workspace, switch on the lights (I imagine I'm a pilot about to fly someplace exciting), open my computer, turn on an audio tape or a podcast, and I get started.

That's it.

I find it hard to draw in silence or to music. My thoughts get really loud and intrusive. If I listen to a story—something completely unrelated to what I am working on—any hint of negative thoughts vanish.

Experiment. Find what *you* like. Build your own habits. Change your habits when circumstances change. My main philosophy is that it is OK to think before you start drawing, and it's OK to think once you've finished your drawing. But while you draw, let your hand move and your mind wander.

I hope this book will encourage and inspire you to draw and that you'll discover for yourself that you can draw anywhere and at any time. So, depending on what your personality is like, line up your crayons or scatter them all over the table, and let's get started!

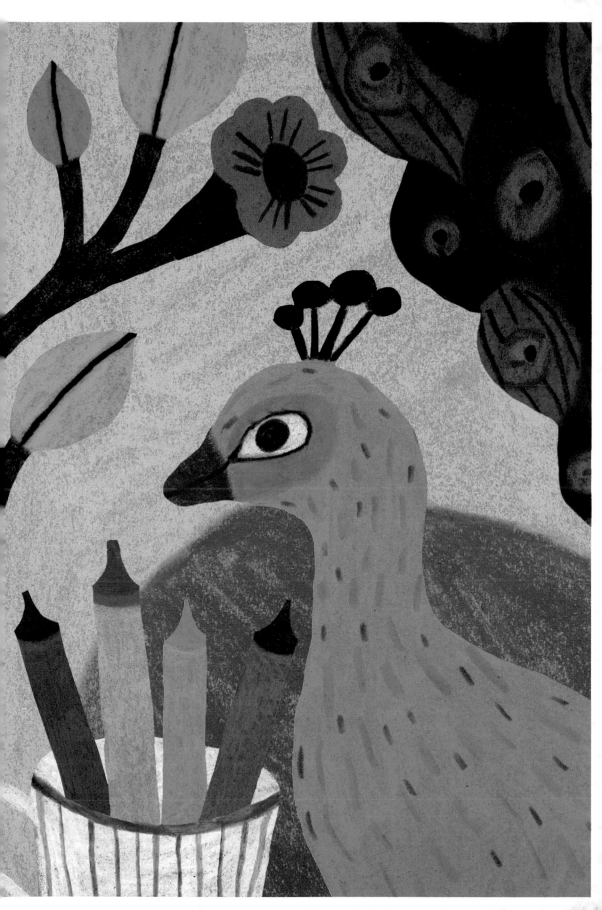

TOOLS & MATERIALS

To create the art and ideas in this book, I used water-soluble wax crayons, oil and chalky pastels, and a wide range of paper types as well as a brush, scissors, and glue. All of these are simple and portable, so you can take your art materials with you wherever you go. Here are some tips for using these approachable, accessible tools.

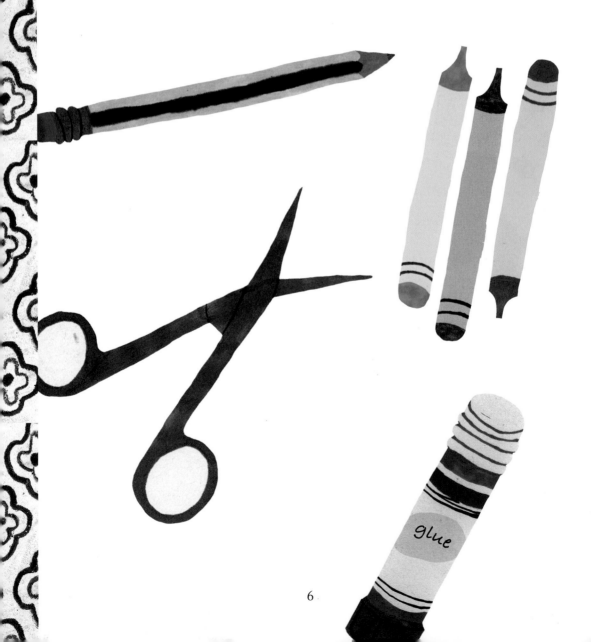

glue

WATER-SOLUBLE WAX CRAYONS

These crayons are *wonderful*; they have a lovely buttery feel when drawing, and the colors remain bright and vibrant when used with water. They make for fluid and fast work, and they are water-soluble too. There are a few different brands, so search around to find one that suits you.

OIL PASTELS

Oil pastels are opaque and have a thick consistency between a solid and a liquid. Rich in color, they work like pastels, but because of their oil content, they blend more smoothly. Oil pastels, which repel water when painted over, work wonderfully as a resist for water-colors in mixed media.

PASTELS

Pastels remind me of the spring sky in my hometown in Sweden: intensely colorful yet light, clear, and soft. Pastels layer nicely, so you can build up layers to achieve a rich hue.

Remember that pastels are dry and chalky and will leave quite a bit of dust and residue, especially when used on smooth paper. Bear this in mind if you use these to draw while curled up on your sofa wearing white jeans; you may end up with a rainbow of colors on the paper *and* on yourself. Note: Using a fixative is *definitely* necessary with pastels.

TIP

When using a crayon, add a bit of water with a wet brush until you can lift the pigment off the crayon. This technique works well for a wash or to add some definition to a piece.

PAPER

Experiment with different textures of paper. Expensive paper is not necessarily better, but cheap paper may yellow with age and can change your image.

I prefer smooth-ish paper with a bit of "grip." Cheap brown wrapping paper is great to use while you're learning. I also love drawing on inexpensive, off-white construction paper. Its slightly off-white color gives a bit of depth and life to a drawing. Also try drawing on wood and fabric as well as on paper.

JOURNAL

I keep a journal or sketchbook not just to sketch in but also as a spot to gather ideas and inspiration and to keep as my reference library. For example, I keep a journal full of leaves I've picked up during my walks around London. I stick them in my sketchbook journal with an adhesive plastic film, and later I can look up the shapes of any leaf I want to draw.

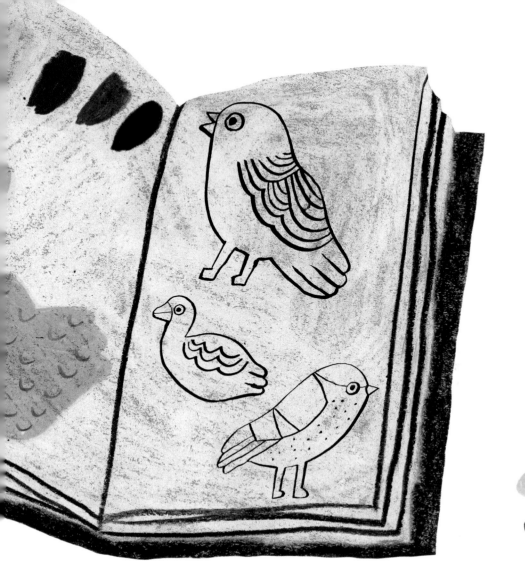

OTHER TOOLS

Pencil or crayon: I prefer to sketch things with a light-colored crayon, but you can also use a pencil. A light-colored crayon or pencil can easily be covered by future layers of color.

Paintbrush: Use a paintbrush to blend, smooth, and define. I use a very fine brush for details. If I want to cover a large area, I use a knife to shave off some crayons into a bowl, and then I use a larger brush dipped in water to mix and dissolve the crayons.

Scissors: If what you draw turns out wrong, cut out the bits you do like and use them in a collage.

Glue: To affix the bits of a collage, use anything from a glue stick to multi-purpose glue or collage glue.

Fixative: Use fixative to avoid a big mess and keep crayons, pencils, and pastels from rubbing off.

Sharpener: Your crayons will need sharpening to maintain a point and create detail.

TECHNIQUES

When I first buy new tools or materials, I like to get a large piece of paper and just doodle, splatter, and splash, a bit like a child playing. See what you can do with your new stuff, whether it's crayons, a paintbrush, or pencils. Me? I love crayons, and because they're so affordable, I don't feel guilty playing around with them.

Grab a large sheet of paper, and see what your crayons can do. Draw large, swirly circles and lots of little dots. Apply different amounts of pressure, make marks, add water, and blend the colors. Spend some time getting to know your materials. The more you use them, the less they will intimidate you. Try different types of paper; you'll be surprised at the difference that makes. The same applies to colors. If you don't like certain colors, see if you can learn to love them by using them with colors that you *do* like. Ask yourself as you work: How can I make all of this *sing*?

Once you get the hang of making marks, you can start creating crayon drawings. Different techniques are used to create lines, textures, blending, shading, and coloring. Let's explore some of them now.

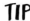

TIP

Grab a sheet of paper, and see what your crayons can do.

11

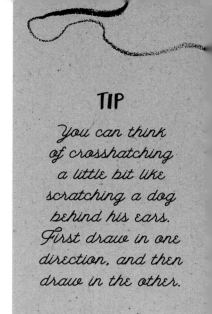

TIP

You can think of crosshatching a little bit like scratching a dog behind his ears. First draw in one direction, and then draw in the other.

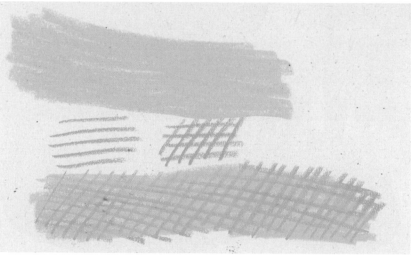

HATCHING

Hatching and crosshatching are great, easy ways to create shading, values, and textures in your drawings.

Parallel hatching consists of rows of lines drawn parallel to one another and close together. Draw two layers of parallel lines at right angles to create a meshlike pattern. Vary the spaces between the lines to create different tonal effects.

Take a look at the illustrations above, which show different ways of hatching and cross-hatching. I added a gray-blue color at the bottom for extra depth and richness. This example is a little bit crude, but with practice, you can achieve fantastic depth and gradients using hatching and crosshatching.

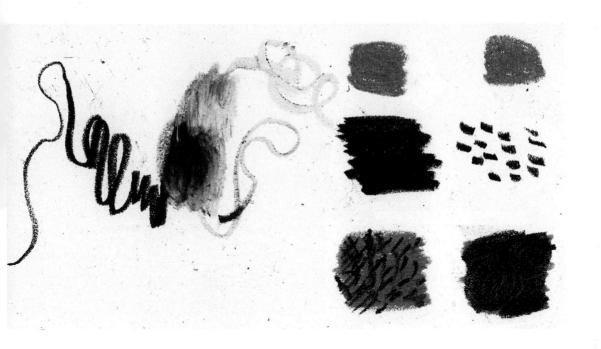

TEXTURE, LINES & SPACING

Make dots or squiggles over a flat color to add texture. Draw squares, circles, and lines. Create lines of different thicknesses, and add varying spaces between them. Ask yourself: What happens if I do *this*? Study different techniques, and then add your own little quirks.

Here, the blue crayon with purple dots on top creates a textured area. Next to it, blue plus purple create a smooth, rich color when applied with normal pressure. Stippling, a technique in which you draw dots all over an area, creates a strong texture.

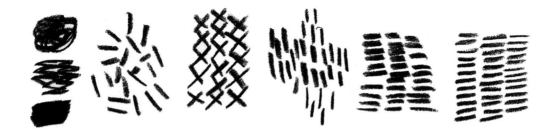

Here are more examples of different textures that you may want to use in your drawings. Which effects could these textures create?

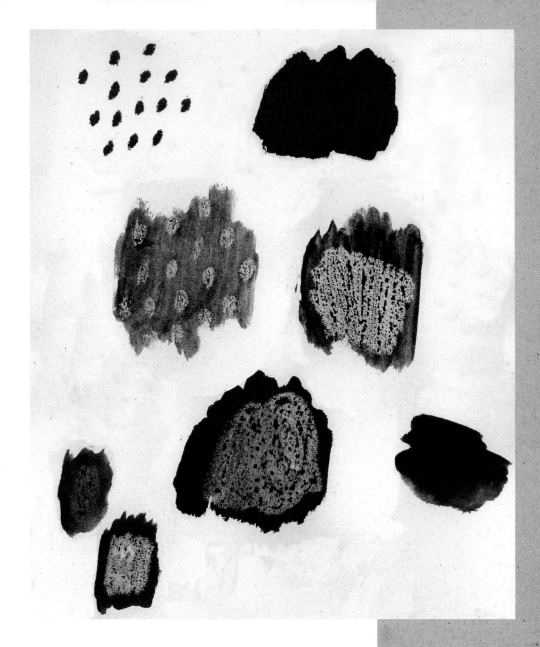

RESISTANCE

You can also create texture by using a water-resistant oil pastel and some watercolors. Take a look at this example. First, I drew dots with an oil pastel. Then I painted over the dots with a red watercolor. The oil in the pastel "repels" the watercolor and creates a nice texture. The rest of this example just shows you how I experimented with this technique . Play around with it!

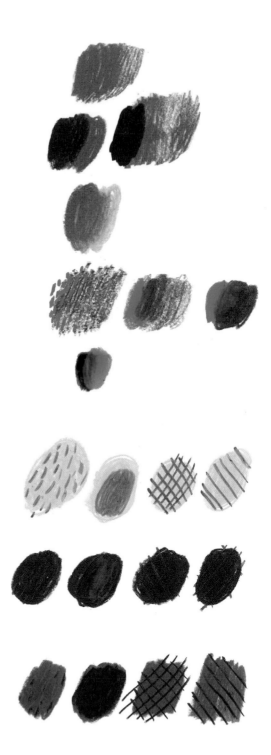

PRESSURE & BLENDING

Apply different amounts of pressure to the crayon when you draw. What happens if you apply full pressure, and then draw over it with a crayon of a different color? Compare the outcome with what happens when you apply lighter pressure to crayons of different colors. Now try drawing with a lighter shade of crayon and then adding a darker color on top. Then do the reverse. What do you see?

LAYERING

One method for blending crayons is to layer a color directly over another. Use as many colors as you want to create the color that you want.

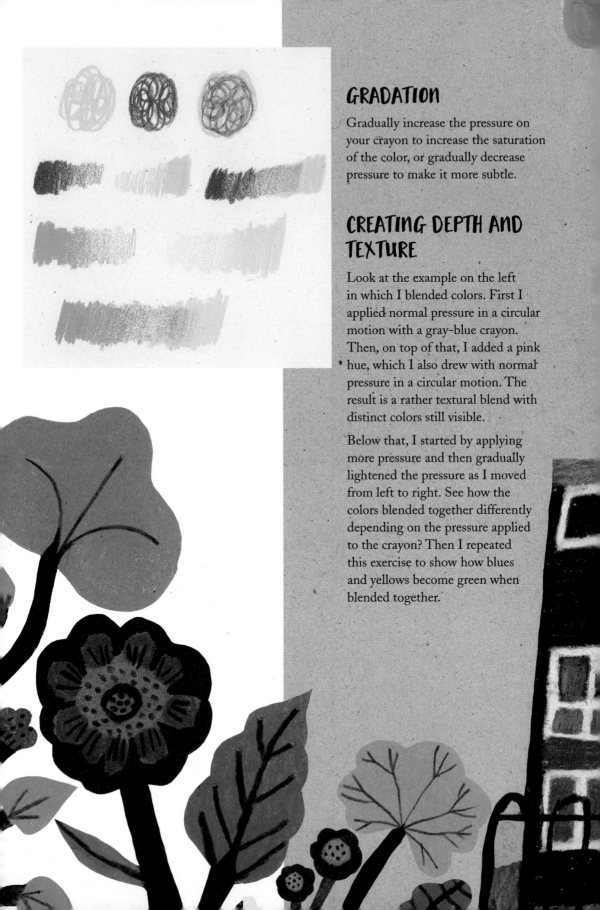

GRADATION

Gradually increase the pressure on your crayon to increase the saturation of the color, or gradually decrease pressure to make it more subtle.

CREATING DEPTH AND TEXTURE

Look at the example on the left in which I blended colors. First I applied normal pressure in a circular motion with a gray-blue crayon. Then, on top of that, I added a pink hue, which I also drew with normal pressure in a circular motion. The result is a rather textural blend with distinct colors still visible.

Below that, I started by applying more pressure and then gradually lightened the pressure as I moved from left to right. See how the colors blended together differently depending on the pressure applied to the crayon? Then I repeated this exercise to show how blues and yellows become green when blended together.

EXPERIMENT!

The more confident you feel, the easier things will get. Trust me: You will gain confidence simply by making marks and squiggles.

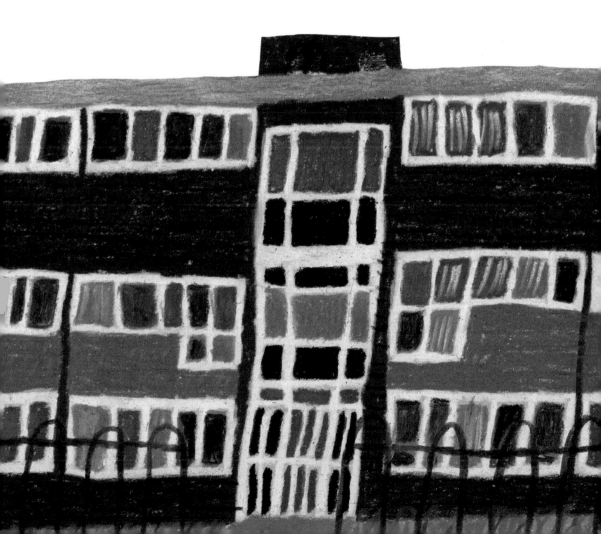

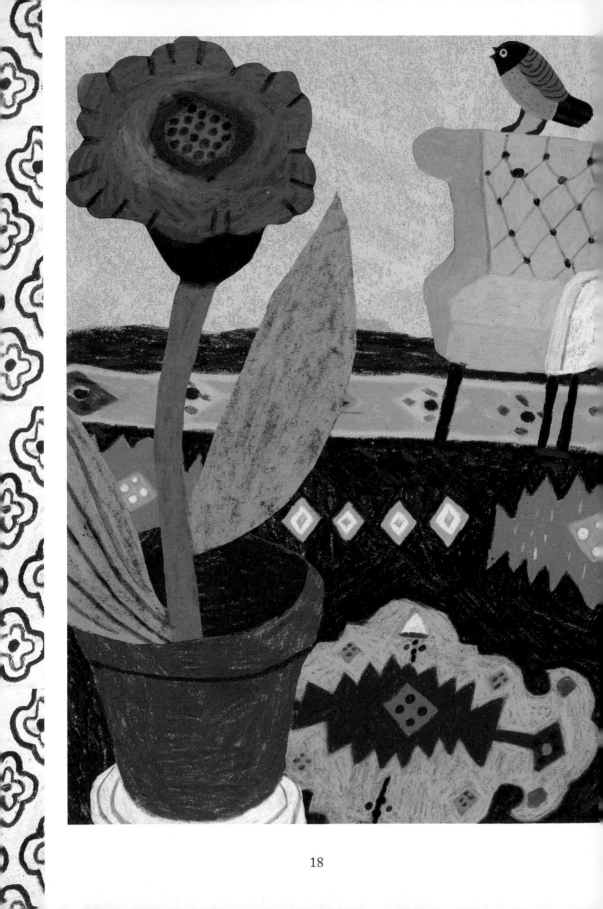

Color is all about
experimentation ...
or maybe rebellion.

COLOR THEORY BASICS

"But you don't know anything about color theory!" exclaimed the person who knows me best when I told him I was writing about it. He's right: I have always felt confused by the theoretical side of color theory, such as the color wheel, the notion of warm and cool colors, complementary colors, and so on.

When I was younger, I used to visit fabric shops with my mother. We'd look at colors and patterns, but where she'd favor, say, matching blues and purples, I went for bigger jumps, like pink with green or orange and blue. My mother tried to teach me that a blue-and-green combination was never a good idea, but that's one of the "rules" that I've since discarded.

Apart from that, she taught me color theory in a more practical way. Try this: Pick up a fabric swatch, and put it next to another one until you find something that works. Use these colors in your art, and you will have created your own practical guide to combining colors.

A FEW KEY TERMS

It can be helpful to understand a few important terms and concepts before choosing a color scheme and creating your first crayon drawing.

Primary, Secondary & Tertiary Colors

The primary colors are red, yellow, and blue. They are positioned at evenly spaced points around the color wheel and can't be created by mixing any other colors on the wheel.

The secondary colors are orange, green, and violet. These can be created by combining two primary colors. For example, yellow plus blue produce green, and blue and red create violet.

Tertiary colors are created by mixing a primary color with the secondary color that sits next to it on the color wheel. Tertiary colors include red-orange, yellow-orange, yellow-green, blue-green, blue-violet, and red-violet.

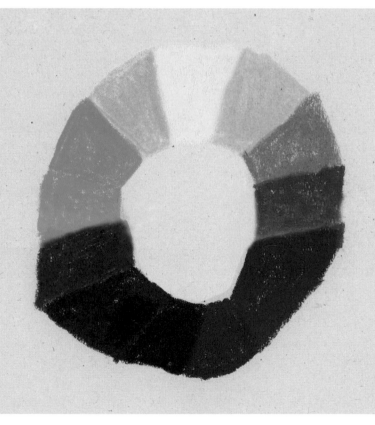

TIP

Familiarizing yourself with the color wheel will help you understand color relationships.

Complementary Colors

Colors that sit on opposite sides of the color wheel are called "complementary colors." Green and red are complementary colors, and blue and yellow are too. The high contrast between complementary colors creates a vibrant look in a drawing.

Analogous Colors

Analogous colors are groups of three colors that sit next to each other on the color wheel. These colors look similar, so they create a sense of harmony and unity when used together.

When choosing an analogous color scheme, make sure there's enough contrast between the colors. You'll want to use different values of light, medium, and dark.

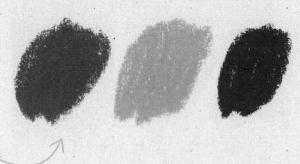

TIP

Avoid using equal amounts of analogous colors. Instead, pick one color as the dominant one, and use it the most. Use a second color slightly less than your dominant one. Then add a third color as an accent to create contrast and variety. This will make your pictures vibrant yet serene when they also feature neutrals.

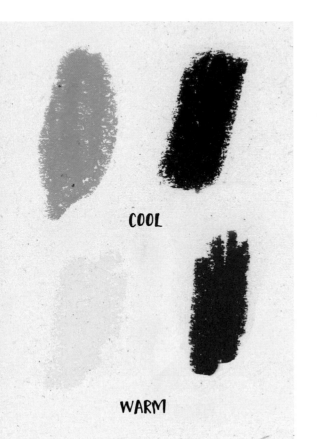

COOL

WARM

Color Temperature

Warm and cool colors don't produce actual heat or cold. These terms refer to the side of the color wheel that they sit on. Warm colors lie on the red/orange/yellow side, while cool colors are on the blue/green/purple half. Color can be used to create mood. Warm colors usually convey energy and excitement, and cool colors evoke peace and calm.

TIP

Warm colors appear to come forward in a drawing, while cool colors appear to recede. This is the principle behind atmospheric perspective, or the method of creating the illusion of depth.

FORGET "THEORY"

When you choose a color scheme for your crayon drawing, set aside color theory, and see which colors *sing* when used together. They say that opposites attract, but two tones of the same color may work too. The best color combinations don't compete with each other; instead, they work together. If you add a third color to the mix, like a neutral, then the bright colors will pop and sparkle.

Putting color theory into use is all about practice. Spend a morning, a day, or even a year experimenting. The thought of creating a finished picture may feel daunting, so my advice is to break things up into smaller chunks. Start with two colors, and then add more as you gain confidence. Try working with warm and cool colors, complementary colors, and analogous colors. Do what feels right, and soon you will learn which colors are your favorites.

COLOR SCHEMES

I picked some colors at random for this illustration and colored the same bird four ways. Which one do you like best? Ask yourself why. What works? What doesn't? Is there a color scheme that you don't like? Why? How would you change it to make it feel more harmonious or exciting?

A color scheme can help you create unity, harmony, or dynamic contrast in a drawing. There are some common color combinations, but you should feel free to play around until you find your favorites!

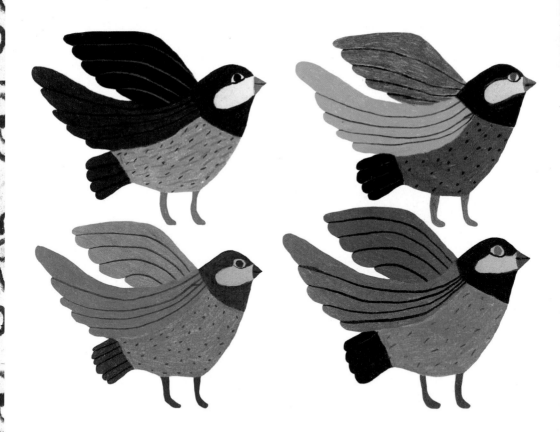

Not Just Brights

An easy mistake when starting out with crayons is to only use bright colors. This can result in a garish or color-intense image. By adding neutrals or darker colors for depth, however, you may end up with a more satisfying picture.

Here's an example. I once lived in a house that had purple tiles and yellow cupboards in the kitchen. It was *insane*. I decided to paint the cupboards pink, thinking it'd go really well with the purple. Had I not seen a picture in an interior-design magazine with that particular color combination, I would have chosen a really vivid pink, and my kitchen might have made my eyes explode.

Instead, I copied the colors from the magazine and bought paint that looked pink next to the purple. On its own, I realized that it was a neutral putty hue with barely a hint of pink in it. But as soon as I put it next to the bright purple, it "changed" and looked pink. Together the colors looked bright yet harmonious. A neutral color such as beige might look gray on its own, but pairing it with another color will change how you see it.

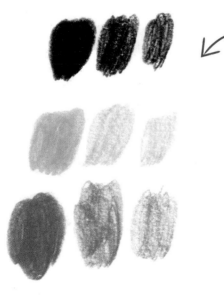

TIP

Neutral colors work well to create a soft, mellow mood.

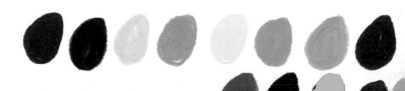

ART ON THE GO

You can draw with crayons wherever you are! All it takes is a little bit of planning and creativity, and soon you'll be creating beautiful, colorful crayon art anywhere and at any time. Over the next few pages, I'll discuss the supplies you'll need on the go, how to find inspiration everywhere, and tips for making drawing a fun, relaxing part of your daily life. Then I'll dive right into crayon drawing exercises and projects.

Let's get started!

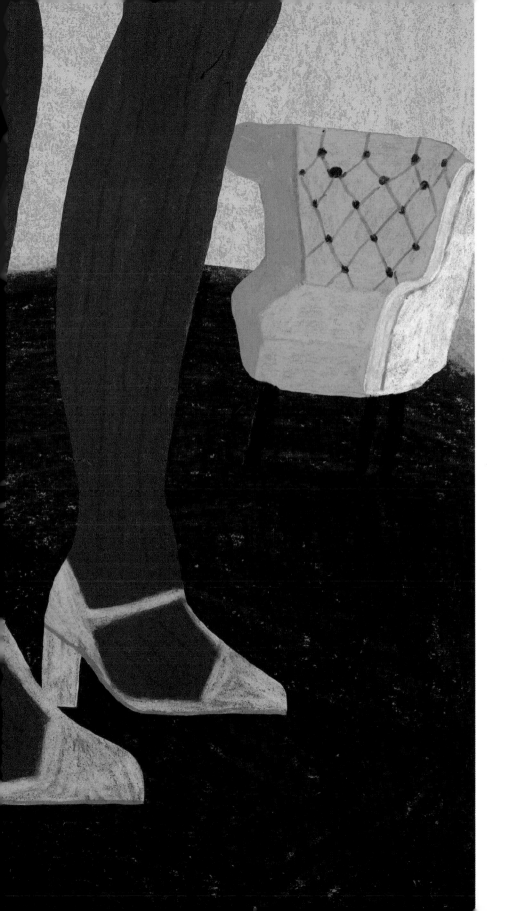

YOU CAN TAKE IT WITH YOU

I used to work as an animator, but for a while, I stopped drawing altogether. Then one day during my son's swimming lesson, I sat and watched people swim. Something happened inside me, and I started rustling around in my bag. I found a crumpled piece of paper and borrowed a pen. I just *had* to draw the people at that swimming pool.

That moment was when I first found my spark and an itch to create. I immediately bought myself a little pocket-sized sketchbook and, from then on, I spent every moment drawing as I waited for my son's swimming lessons to end.

Now I always keep a few creative tools in my bag when I go out: a pencil, some paper, and a little box of crayons. Get into the same habit. I recommend buying a small sketchbook—something that will easily fit into your pocket or bag.

Save that big, fancy sketchbook for when you go out for the sole purpose of drawing. For daily use, get something smaller.

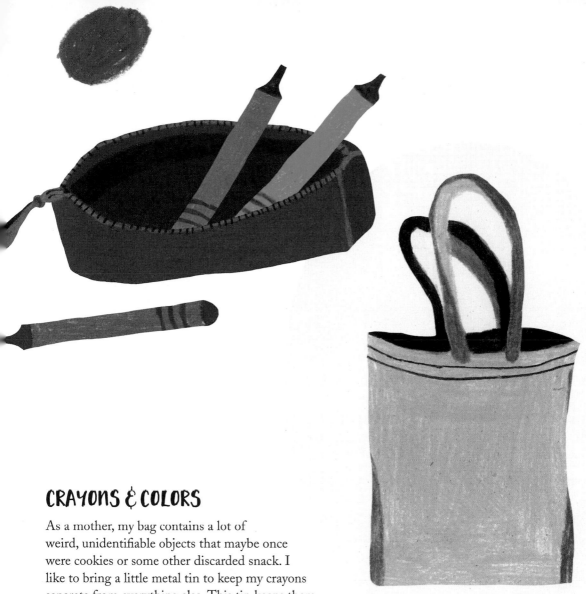

CRAYONS & COLORS

As a mother, my bag contains a lot of
weird, unidentifiable objects that maybe once
were cookies or some other discarded snack. I
like to bring a little metal tin to keep my crayons
separate from everything else. This tin keeps them
from breaking, dissolving, or making the messy innards of
my bag even messier.

It's a small tin in which only about 5 crayons fit. Every week,
I switch out the colors. This forces me to use different color
combinations and find ways to make seemingly clashing colors
work together. It's easy to find a color palette that works—let's
say, blue, red, and gray—and then draw everything using varia-
tions of these colors.

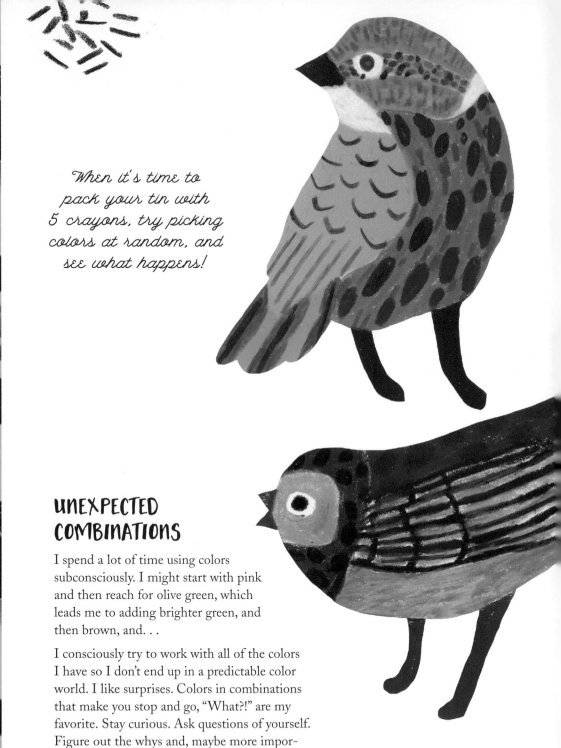

When it's time to pack your tin with 5 crayons, try picking colors at random, and see what happens!

UNEXPECTED COMBINATIONS

I spend a lot of time using colors subconsciously. I might start with pink and then reach for olive green, which leads me to adding brighter green, and then brown, and. . .

I consciously try to work with all of the colors I have so I don't end up in a predictable color world. I like surprises. Colors in combinations that make you stop and go, "What?!" are my favorite. Stay curious. Ask questions of yourself. Figure out the whys and, maybe more importantly, the why *nots* of color.

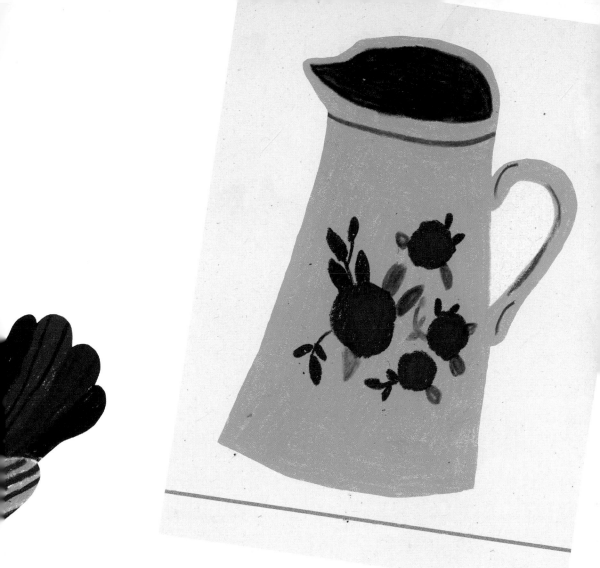

SKETCH IT OUT

When I was in Paris, I went to a flea market (isn't that *just* the thing to do when in Paris?), where I saw the cutest jug among a sea of knickknacks. I couldn't get it out of my head as I walked around. It wasn't anything special, but it had something that drew me in. So after ten minutes, I made my way back and quickly sketched it. I've since then gotten a little bit obsessed with jugs, and whenever I see one I l like, I draw it.

You can do that too: Pick out a subject that you often see while out and about, and sketch it whenever you have a minute. Soon you'll build up a nice collection of sketches of your favorite subject.

PRACTICE, PRACTICE, PRACTICE

A lot of people find it easy to draw dogs but, for me, dogs are so difficult to recreate, even after years of trying. What works for one person can seem like an impossible mathematical equation for another. But that's the beauty in art: how we are all different.

Dogs are still on my list of drawing subjects to conquer. Whenever I see a funny, cute, weird, or scary dog when I'm out and about, I make it a point to do a quick sketch, usually with a pen or pencil.

When this book idea came along, I tried drawing a dog by quickly coloring in the shape of one in light gray and then adding a minimal number of darker crayon lines for the eyes, nose, mouth, and ears. This sketch actually captured the essence of a dog better than all of my previous pen sketches. So if one way doesn't work, even after trying it a hundred times, try switching something: location, materials, your point of view, your focus... Sometimes, practice is all it takes to make perfect!

People often say that it takes three months to create a habit before it becomes second nature. Starting *right now* (not tomorrow), set aside ten minutes a day to draw somewhere other than your home. And follow through on your new plan!

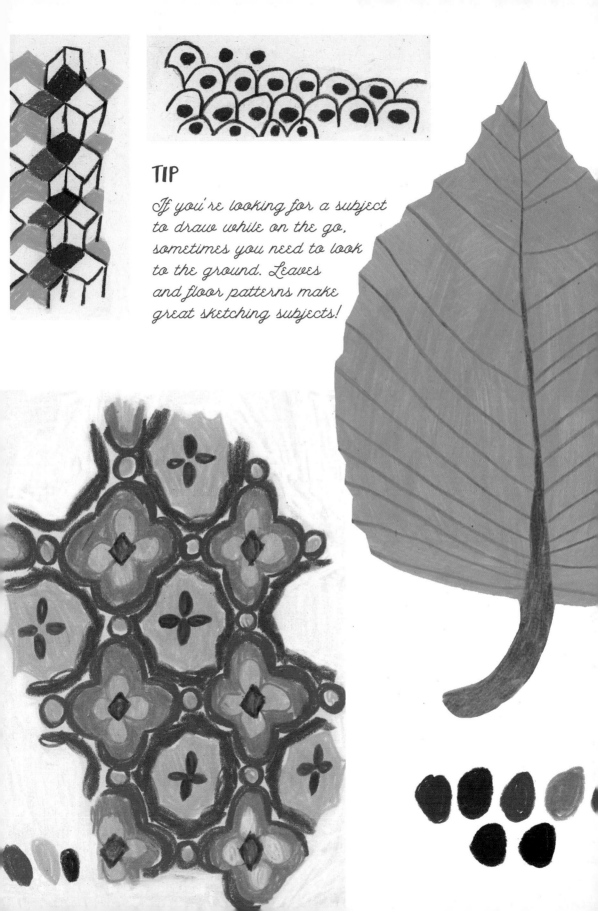

TIP

If you're looking for a subject to draw while on the go, sometimes you need to look to the ground. Leaves and floor patterns make great sketching subjects!

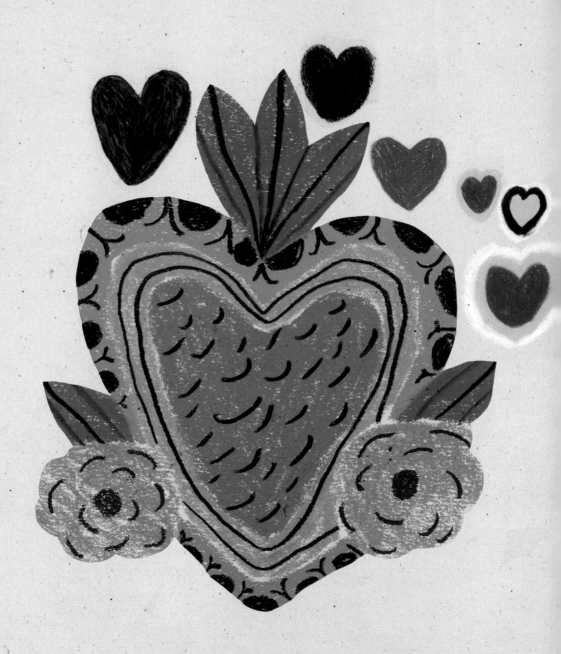

DOODLES

Now it's time to put your newfound skills into practice with some drawing projects! Let's start with simple doodles before progressing to fun, easy subjects like cakes, clothes, and cats.

When I'm attending a lecture, you'll often find me doodling. It can be difficult to sit still, concentrate, listen, and absorb information. Instead of just trying to focus on what I'm hearing, I like to doodle while I listen. I find that this helps me better process the spoken word. In fact, studies have found that doodling can help the brain process information and help you pay attention to and remember the things that you hear. It can also keep you entertained while you wait somewhere. So, doodling is good!

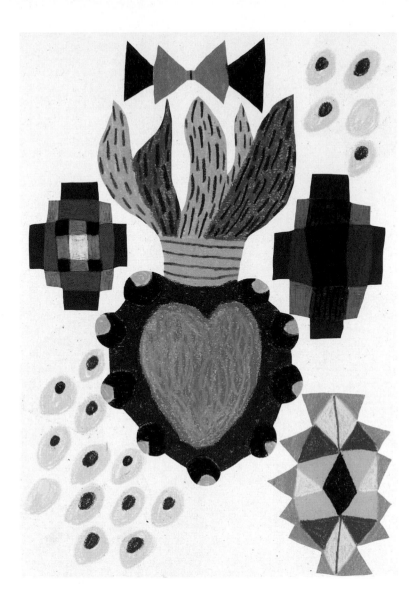

DRAWING A DOODLE STEP-BY-STEP

I was a bit worried about writing this chapter, as I had to consciously think about doodling, which is a bit of a subconscious action. My solution was to make sure I had paper and crayons with me every week when I spoke on the phone with my dad, who lives in Sweden. When we spoke, I doodled, without paying much attention to what I was drawing.

I ended up doodling little lines, squiggles, and hearts, so let's begin our crayon adventure by doodling hearts inspired by Mexican art.

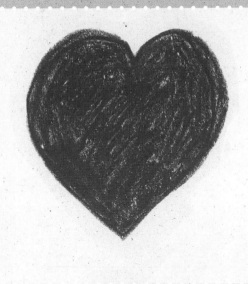

STEP 1

Give these colors a try for your first doodling project. Start by drawing a heart in orange.

STEP 2

Add red over the orange to create rich-ness and depth.

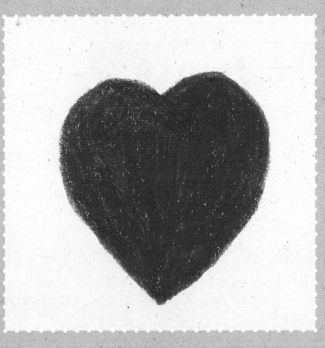

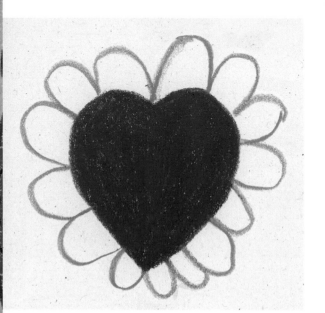

STEP 3

Draw half-ovals around the heart with a pink crayon.

STEP 4

Fill in the end of each half-oval with the same pink crayon.

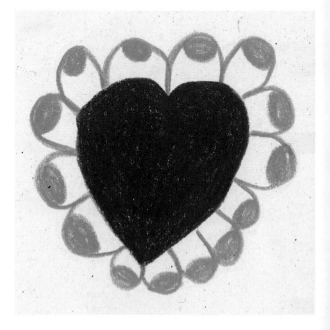

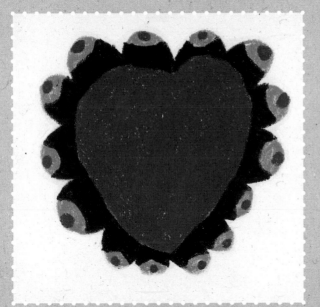

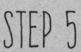

STEP 5

Color in the rest of
each half-oval with dark
brown, and draw a little
red dot on the pink area.

STEP 6

Add fun details to finish up your
doodle. Draw two lines around
the heart shape with a dark blue
crayon. Then add three lines of
dark blue on each brown half-
oval, and you're a doodler!

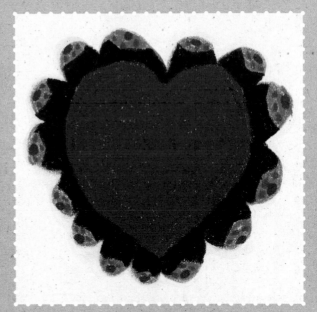

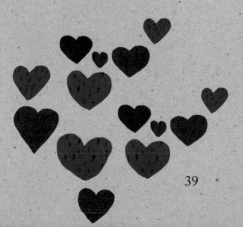

HAVE A **LITTLE HEART**

Once you've drawn a simple heart, you can try adding all kinds of fun details to your heart doodles. Do you like flowers? Fruit? Patterns? Personalize your hearts with all of your favorite details and colors.

IN THE KITCHEN

TEA OR COFFEE & CAKE

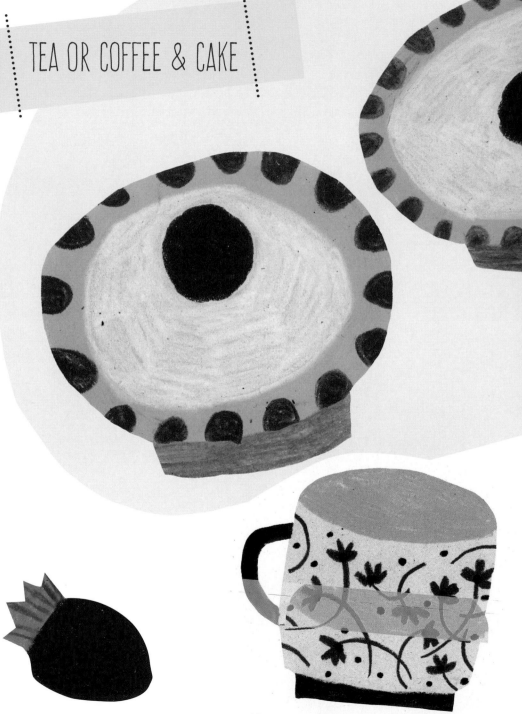

My kids and I like to bake. It usually ends up rather chaotic with us dancing around in a cloud of flour. We're currently working our way through a book of recipes. Our resounding favorites so far are *hallongrottor*, which translates from Swedish into English as "raspberry caves." But we've got our version of chocolate brownies down too.

I baked a lot as a child. I made apple pies with my dad, cinnamon swirls with my mom, and a million types of cookies with my nanny. When I last was in my hometown, I visited my old nanny. We had coffee and she gave me a notebook in which she'd written the recipes of all the cookies we used to bake together. It made me cry with happiness.

Now I love to draw the cookies that I used to bake with my nanny along with the cup of coffee or tea I drink while enjoying my kids' and my sweet masterpieces. Really, anything goes as a sketching subject!

DRAWING A TART STEP-BY-STEP

Now let's try drawing a raspberry tart.

STEP 1

First, draw the shape of the tart base. I drew five half-moon shapes together, which curve in downward on both sides of the cake.

STEP 2

Fill in the tart base. I used a yellow crayon to make it extra colorful. In real life, pastry looks more beige.

STEP 3

Draw the shapes of three simplified strawberries. I used a lighter, warm orange-red to quickly sketch out three rounded shapes that will become strawberries.

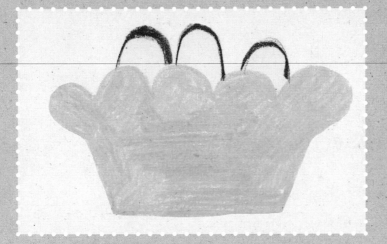

STEP 4

Draw more strawberries. I used a cool blue-red color to contrast with the other strawberries. I drew these mounds between the orange strawberry mounds. Behind those, I drew another three strawberry mounds in dark purple to add depth.

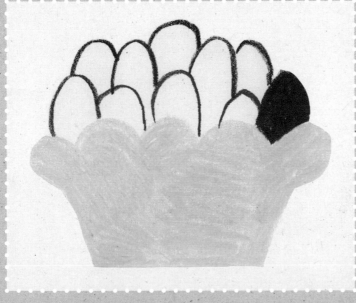

STEP 5

Color in the strawberries, and add lines to indicate texture in the pastry. Now you're done, so let's eat!

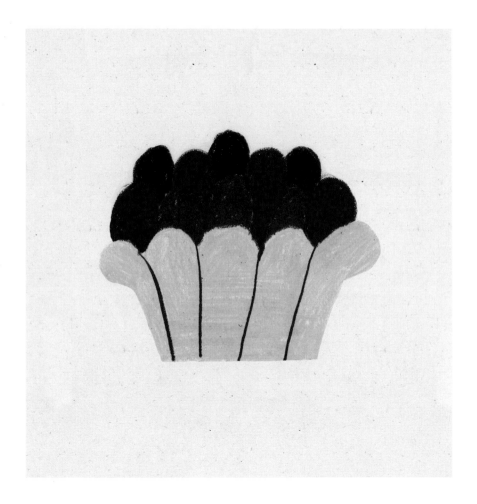

TIP

Items that sit farther back might have a bluer tinge to them to add atmospheric perspective.

TIP

Try adding other fun detail to your drawings of cakes, like a patterned tablecloth or a pretty serving platter.

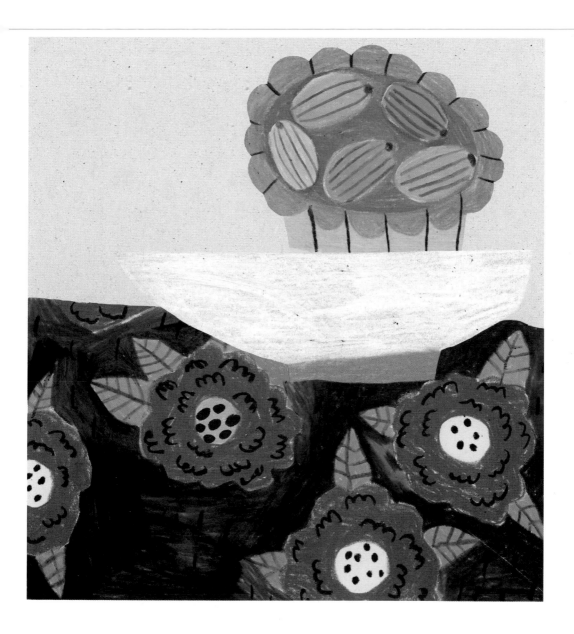

CAKE COLLAGE

I find food challenging to draw. It's full of different textures and details, so using collage is a good way to deal with these difficulties. You can then "bake" a cake using paper.

First draw a cake shape, and color it brown if it's chocolate or maybe use yellow for a yellow cake. Anything goes! Then cut out whipped cream swirls from white paper, and glue them on. Lastly, decorate with toppings of your choice. For example, draw some strawberries on a separate sheet of paper, cut them out, and glue them onto the cake. *Voilà!* Your cake is done, and you didn't even have to bake it!

TIP

Once you've mastered drawing and collaging cakes, you can use the same basic process to draw all types of food items.

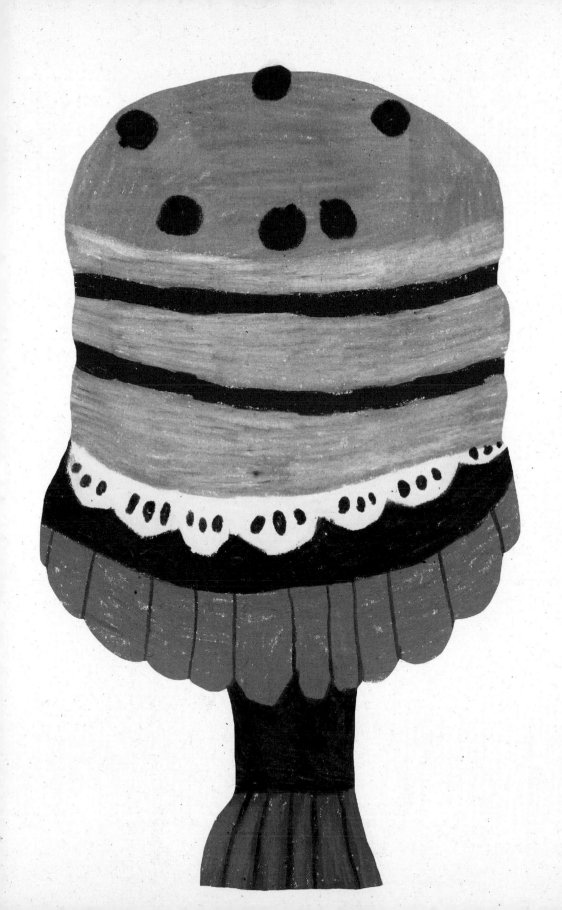

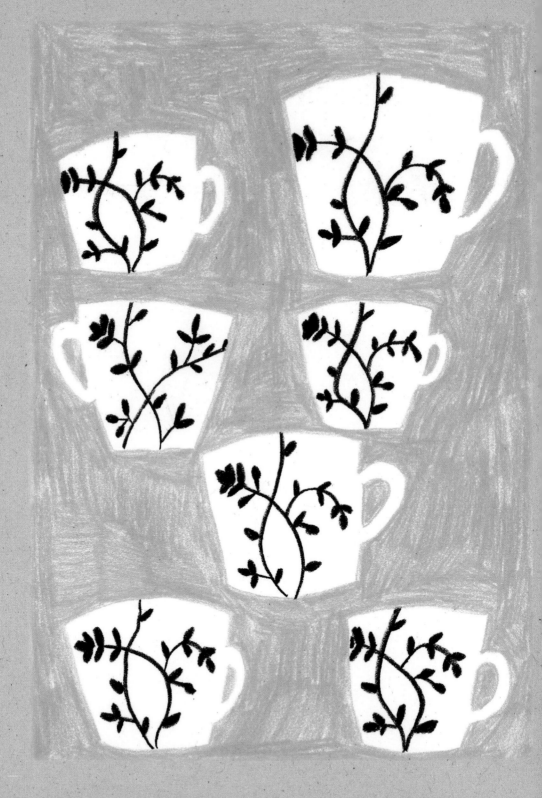

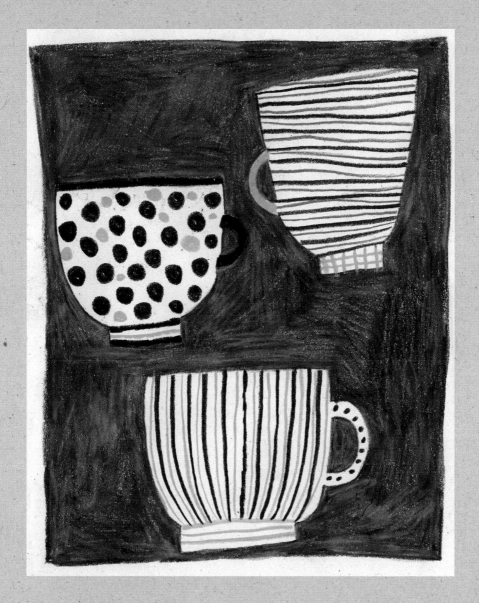

MUGS & TEACUPS

What goes better with cake than tea or coffee? Teacups come in all different shapes, sizes, and colors, and they don't run around or wriggle or bark. This makes them the perfect subjects for practicing drawing from life.

Starting on page 52, I've shown you how to draw a simple cup. You can draw the same cup every day for a month, or you can document all your different cups. You can also try creating cups with patterns that you've invented! I love to pick up quirky old cups from thrift stores and antique shops. It's so much fun to imagine where the cups have lived before. Do you have a favorite cup? Practice drawing it!

DRAWING A MUG OR TEACUP STEP-BY-STEP

What better way to draw a mug than to enjoy a cup of something hot as you work?

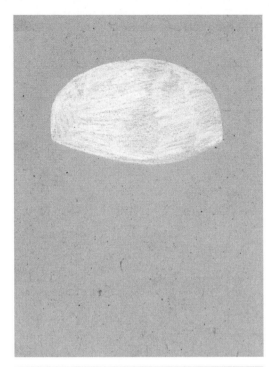

STEP 1

I like using white crayon on a neutral background, as it looks very crisp. Start by drawing an oblong shape to form the inside of the cup.

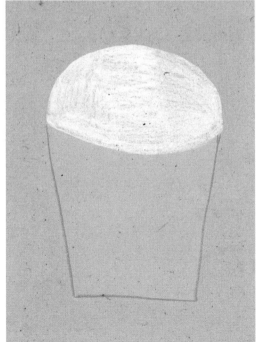

STEP 2

Sketch the shape of the cup itself. Remember: The bottom of a cup is narrower than the top.

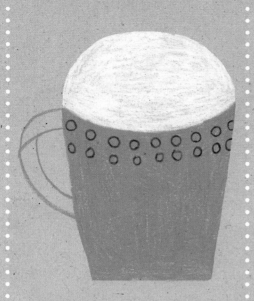

STEP 3

Draw the handle as two half-circles next to each other, and color in the mug. Draw two rows of circles with a darker blue crayon.

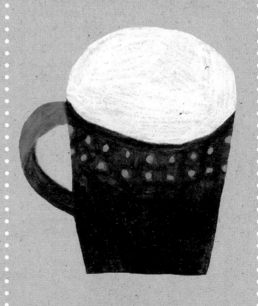

STEP 4

Add darker blue over the lighter blue crayon, leaving the handle light blue. Divide the handle in half, and color just the bottom part dark blue. Now let's have a cup of coffee or tea ... and maybe some cake!

AT HOME IN THE LIVING ROOM

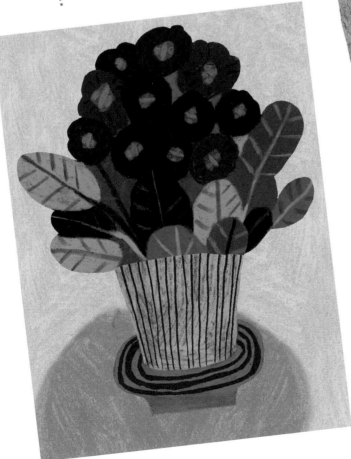

I grew up in northern Sweden, where it is dark, bare, and snowy half the year, and people love to decorate their windowsills with plants. I brought this habit with me when I moved to England and always keep plants around my home. Another thing I like? Really colorful chairs!

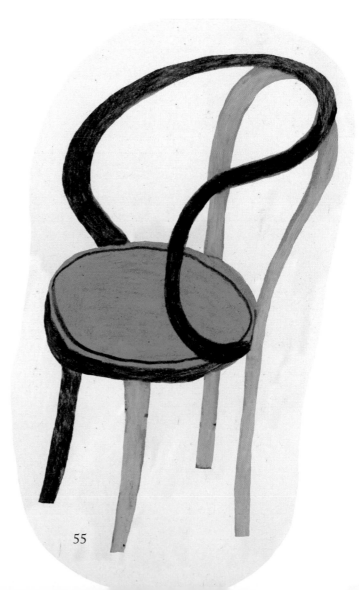

DRAWING A HOUSEPLANT STEP-BY-STEP

The plant in this project had a simple white pot, but I thought it could look even nicer with some blue-and-white doodles on it.

STEP 1

Draw the shape of the pot, leaving space for the plant, and then color it in. I used a white crayon. Most plant pots are wider at the top and narrower at the bottom. Add curves to make it a rounded pot.

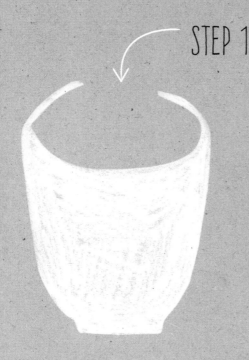

STEP 2

Draw the soil in a light-brown color, and add texture by making some marks—crosshatching or dots will work—over the light brown using a darker brown crayon.

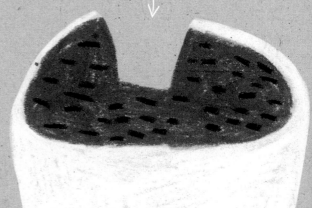

STEP 3

On a separate piece of paper, doodle some patterns. Then draw one of those patterns on the pot. Anything can provide inspiration: a teacup, a quilt cover, a dress pattern...
For example, the inspiration for this pot was something I saw in a shop. When I got home, I tried to recreate that pot and its pattern as I remembered it.

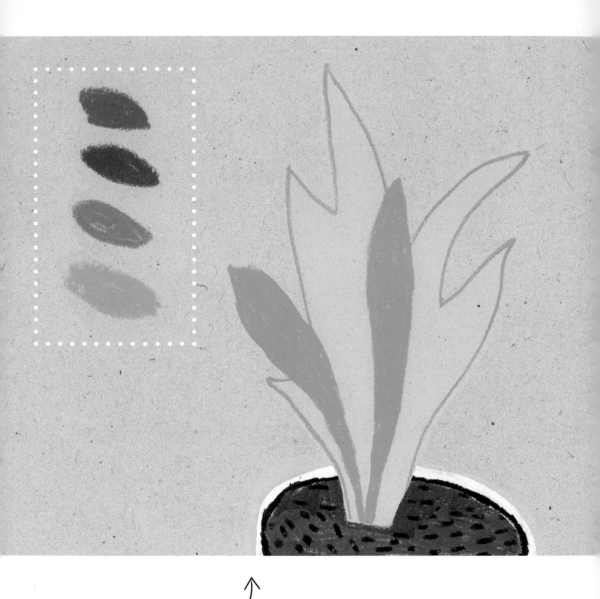

STEP 4

Now it's time to sketch the plant itself. I picked a few different shades of green plus a lavender-blue color. I sketched the shape of the plant with a light mint-green color and colored in two of the leaves.

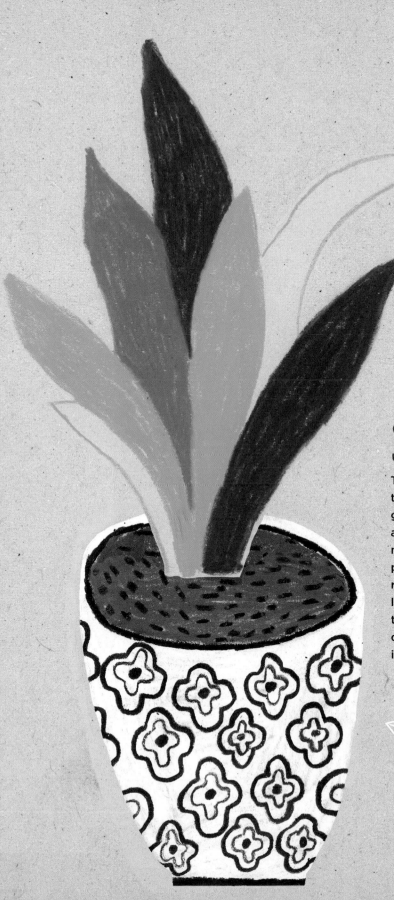

STEP 5

Then I colored in another two leaves with dark green and one leaf with a more neutral green to make the brighter greens pop. I made one of the remaining two leaves a light yellow-green and the other a lovely lavender-blue to give the image some depth.

STEP 6

Finally I added texture, and I drew the veins of the leaves using the green and brown crayons.

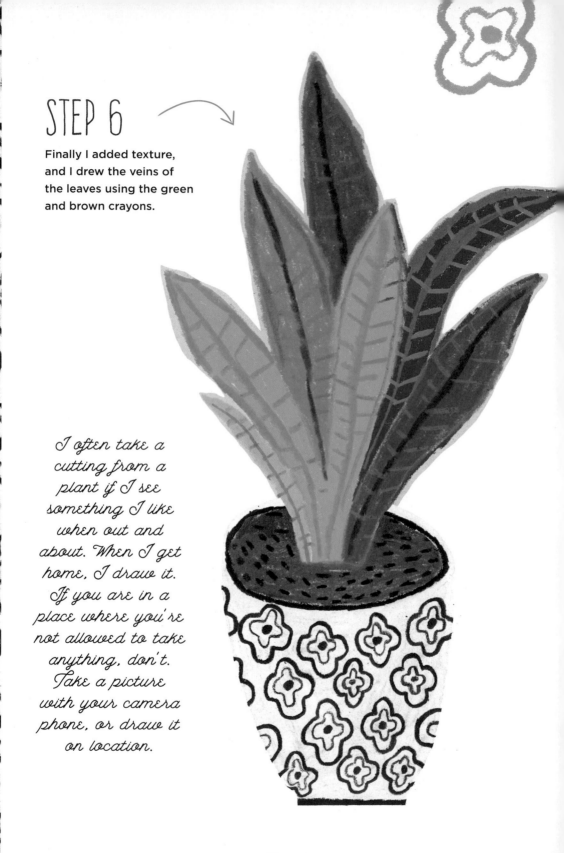

I often take a cutting from a plant if I see something I like when out and about. When I get home, I draw it. If you are in a place where you're not allowed to take anything, don't. Take a picture with your camera phone, or draw it on location.

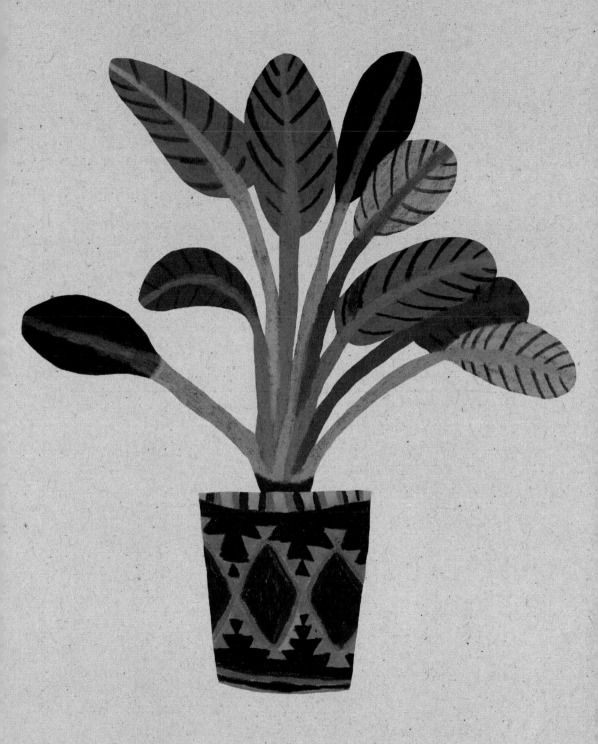

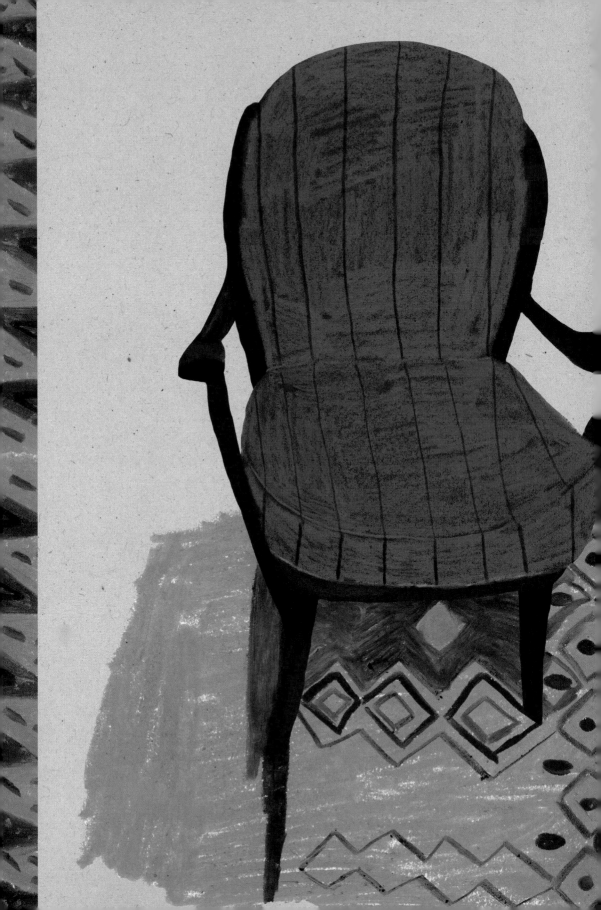

CHAIRS

In my family's home, we have all sorts of chairs, each with its own personality. There's the big old comfy armchair and the even more comfortable hammock chair outside on the balcony. We have a stylish rocking chair and a few folding chairs. The kitchen chairs, which I inherited from my grandparents, date back to the 1940s. They're simple and understated and we use them every day.

Some chairs are all straight lines, while others consist of curves or upholstery. Chairs can be detailed or more minimalistic in design. If I see a nicely shaped chair, I usually take a quick photo or sketch it.

Find the way that works best for you to sketch and draw. I draw very quickly, sketching out the main shapes in one fell swoop, and then I take my time filling in the details. Other people work more meticulously and slower. There is no right or wrong way; determine *your* preferred method for drawing.

Get into the habit of observing what's around you. Pay attention to the shapes in your everyday life. What do things look like? How do they move, and how are they built?

The art of observation helps create a great internal library of inspirational imagery.

DRAWING A CHAIR STEP-BY-STEP

This yellow chair belongs to a friend of mine, and it's not really bright yellow. It's actually upholstered in a dark purple fabric, but I thought yellow would look even nicer. That is the beauty of art: You can draw your subjects however you like.

Also play around with different ways of drawing floors. Next time you're standing on a garish carpet, draw or doodle it. Here are some doodles that I like to use as inspiration.

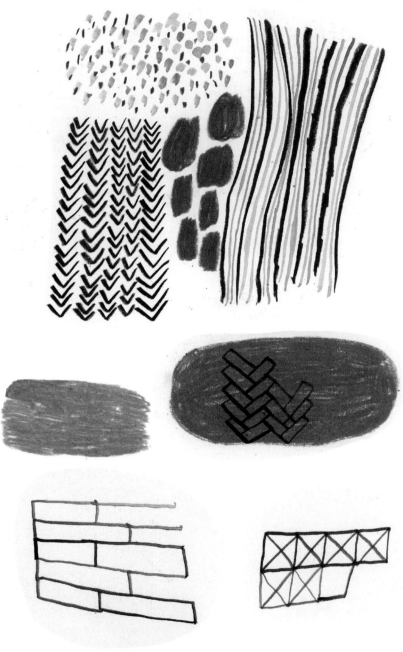

STEP 1

Choose a color for your chair. I picked a sunny yellow. Start by sketching the shape of the chair. Fill in these lines, or use a crayon to draw the seat and back of the chair.

STEP 2

Draw the legs of the chair. I used beige and dark brown crayons for mine. Then draw the buttons with a dark brown crayon.

TIP

If you use a pen or dark crayon to sketch, keep in mind that the lines may be difficult to cover up later.

STEP 3

To show the creases in the fabric around the buttons, I picked a muted lilac color. With a watercolor brush, a water-soluble crayon, and some water, paint little lines by each button.

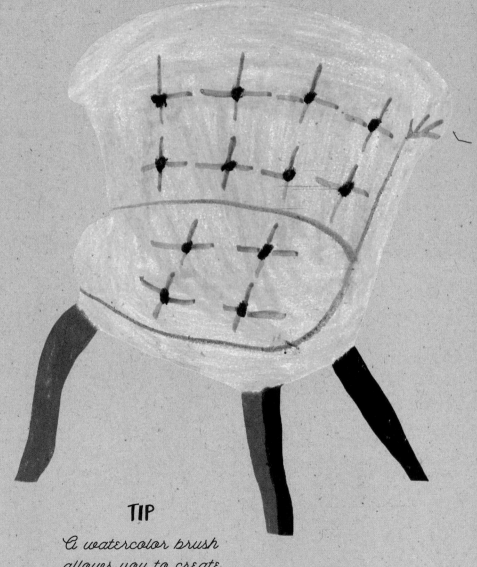

TIP

A watercolor brush allows you to create finer details than crayons will.

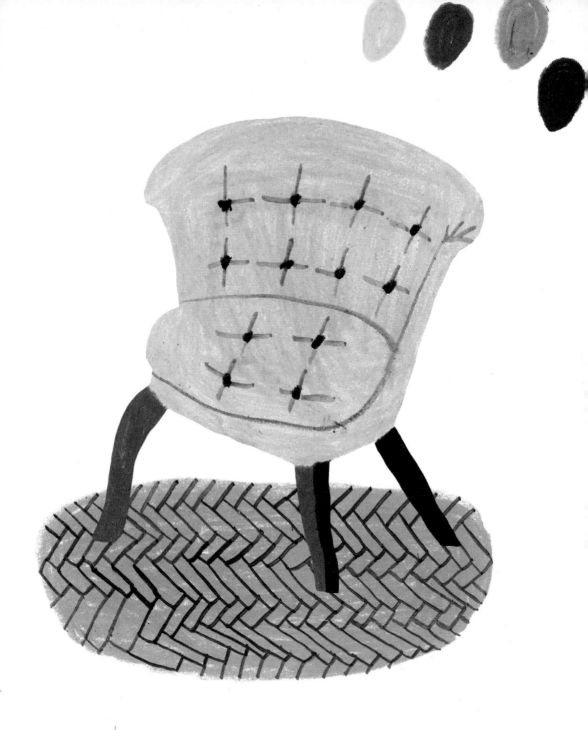

STEP 4

Draw the floor with a beige crayon. Then grab the dark brown, and using the watercolor brush, paint the floor pattern. Ta-da! You have a chair!

On average, children spend a half-hour
a day coloring. Why not invite your kids
to join in the crayon fun?

Crayons are nostalgic items for a lot of people. Did you know that the scent of Crayola crayons is one of the 20 most recognizable scents, according to a Yale University study? It's no wonder crayons are the perfect tool for drawing your grandmother's armchair or your favorite houseplant!

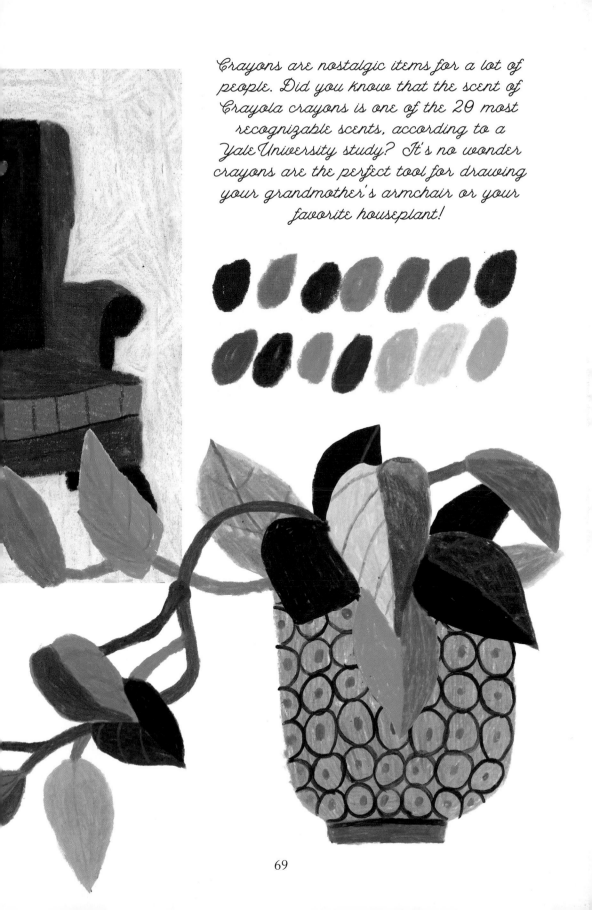

WHAT WE WEAR

FOOTWEAR & FINERY

I love drawing shoes. The more uncomfortable they are to wear, the more interesting they are to draw. They're like miniature sculptures!

Imelda Marcos, who served more than 20 years as the first lady of the Philippines, was infamous for her large shoe collection. She left behind a staggering 1,220 pairs of shoes. Wouldn't it have been amazing to draw them all?

While my wardrobe doesn't have as many shoes as Imelda's did, I do have lots of crayons. I spent a few days drawing some of my own shoes and also some of my friends' shoes. It was heaven! Now let's look at some of the shoes I've practiced drawing and then learn how to draw a shoe.

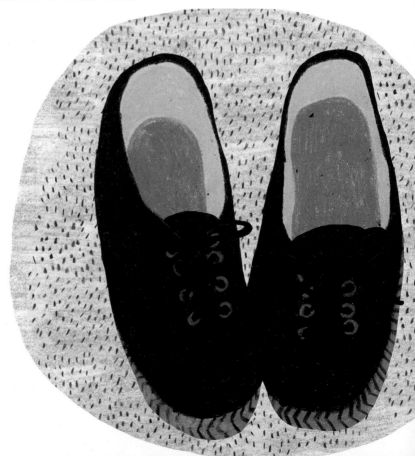

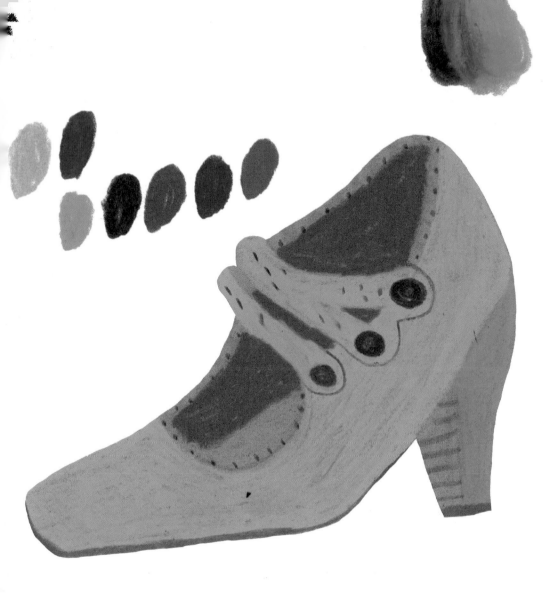

TIP

Your shoes will need to stand on something! See the flooring doodles on page 64 for ideas.

DRAWING A SHOE STEP-BY-STEP

Brogues are often considered men's shoes, but they can also feature a heel for a more feminine look.

STEP 1

If you look at a pair of brogues from above, you will see the inside bottom of each shoe. It looks a bit like an arched window. Draw this shape, with the bottom curved, in a dark color to match the inside of a shoe.

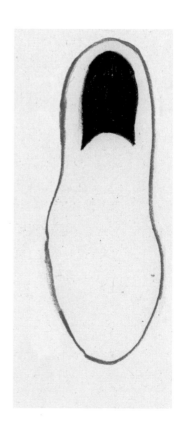

STEP 2

Make a quick outline of a shoe on a piece of paper by loosely drawing around your own foot. You will then have a shoe shape!

I drew this shoe shape from life. Notice that the heel is narrower than the front and that the sides aren't exactly the same.

STEP 3

Color in the shoe. I picked a light gray for my brogues.

Then it's time to give the shoe definition. First, draw a half-moon shape to mark the shoe's tongue. Then draw holes for the shoelaces. A brogue has flaps, and the shoe's tongue lies underneath the shoelace holes to give it a snug fit. I drew two shapes to show this opening.

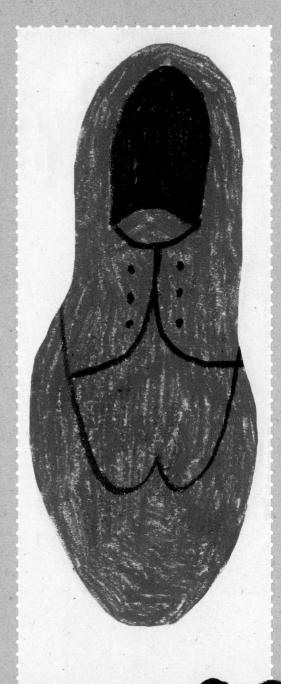

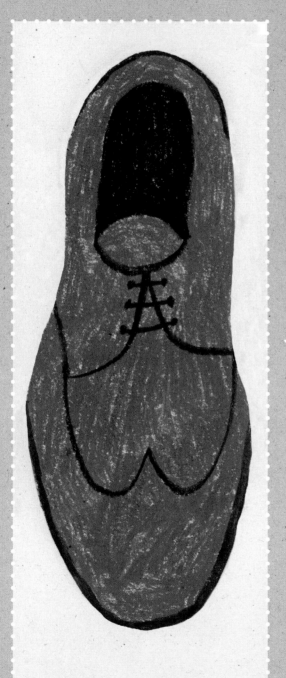

STEP 4

Now add even more details. Brogues often have visible stitching, and you can have a lot of fun drawing this. I opted for minimal fuss and decoration.

I added shoelaces in a reddish-brown that's visible against the gray shoe. I also used this color for the sole of the shoe.

Feel free to add decorative details to your shoes!

SHOE-SPIRATION

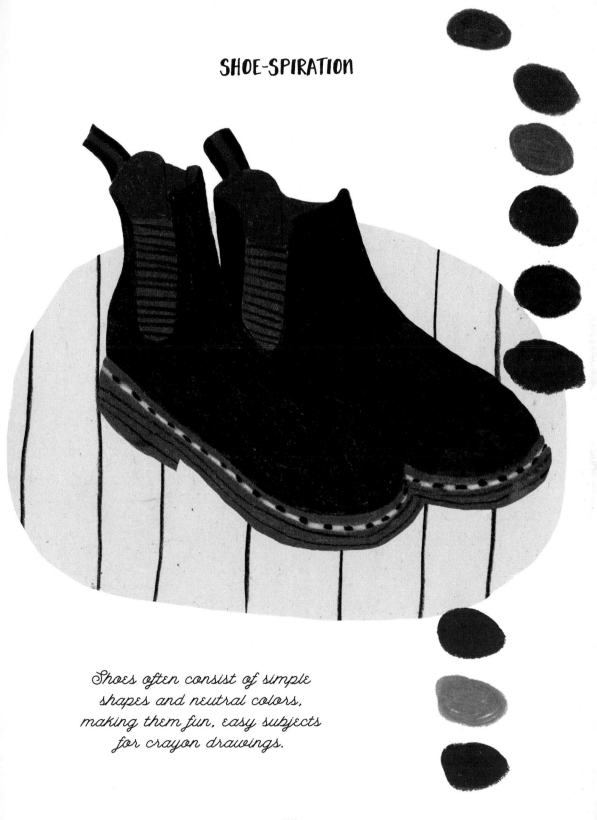

Shoes often consist of simple shapes and neutral colors, making them fun, easy subjects for crayon drawings.

CLOTHING QUEST

A friend of mine has a fantastic wardrobe of clothing. It's a bit like walking into an untidy cave of colors and textures. It's the crazy mixed with the serene. She won't turn up to meet you wearing jeans and a T-shirt. Instead, she will come dressed in a mixture of fancy and fabulous. I wanted to draw her clothes for this chapter, but that plan didn't quite work out.

I then had to go with my plan B and draw my own not-nearly-as-interesting wardrobe. Surprisingly, I found this to be great fun. You don't need outlandish colors or avant-garde outfits to make sweet drawings. The good thing about drawing is that you can mix imagination with a bit of reality.

I used the shapes and patterns of my clothes as a guide, and then I altered colors and added details, just because I felt like it.

Viva artistic freedom!

76

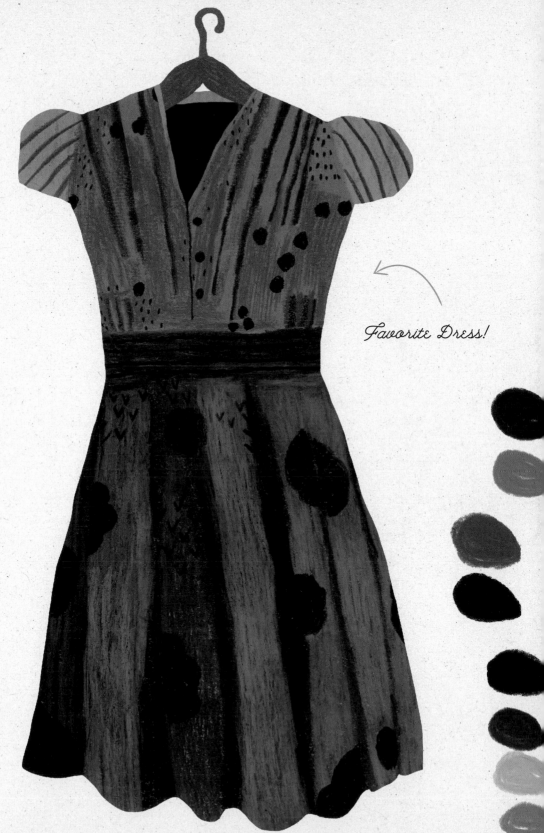

Favorite Dress!

DRAWING A DRESS STEP-BY-STEP

This is another one of my favorite dresses. In real life, it's not pink and floral patterned. I took some artistic liberty to make my own dress look a little more fun!

STEP 1

Start by drawing the simple shape of the dress. It should look almost like a vest, but stop just under the armholes.

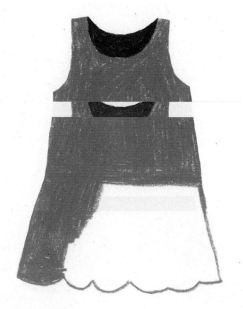

STEP 2

Draw the skirt part of the dress with scallops at the bottom. Add the neckline at the back using a darker crayon to give it some definition. Color in the dress with more pink.

STEP 3

With a red crayon, mark where the fabric has been stitched together. I chose to make the buttons on the dress a contrasting dark blue.

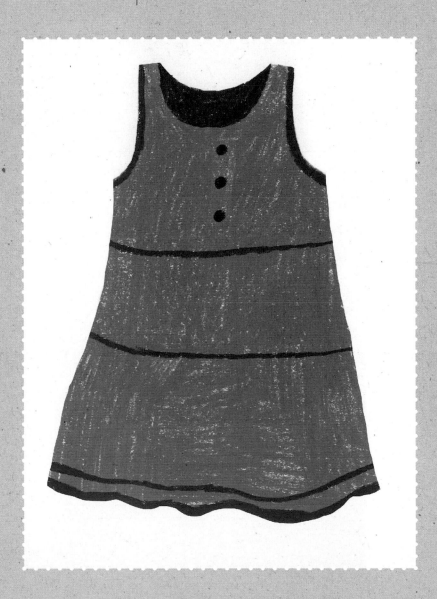

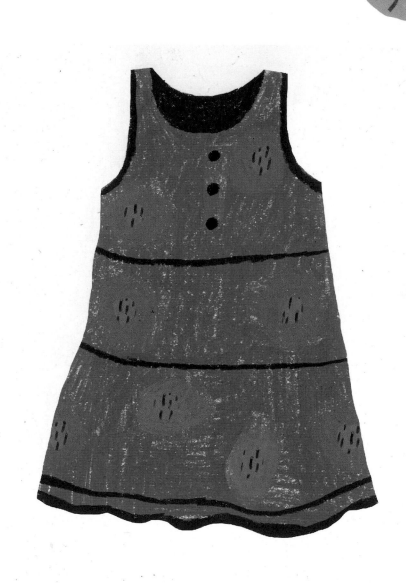

STEP 4

This dress has an oversized floral print, which I drew with a gray crayon. I also added dark blue dots for more details.

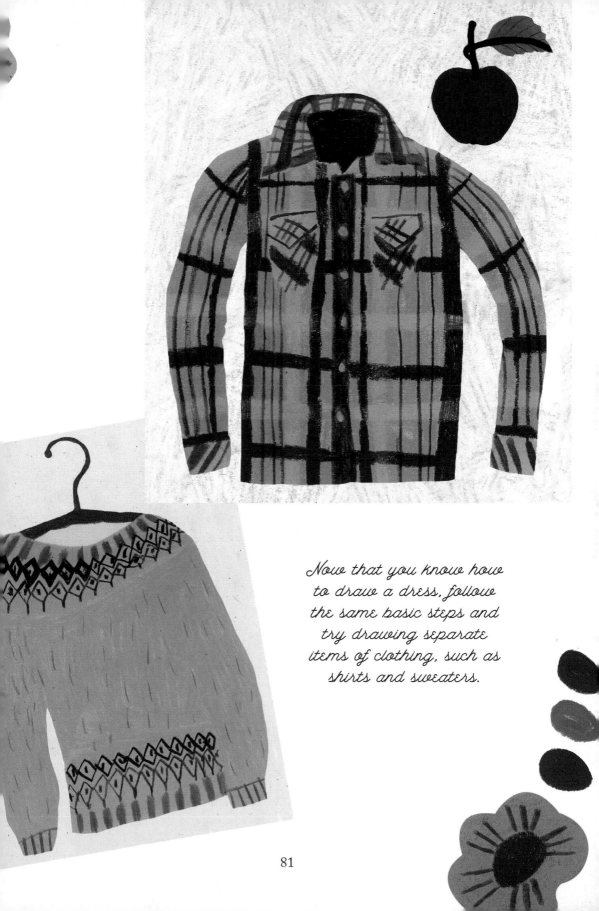

Now that you know how to draw a dress, follow the same basic steps and try drawing separate items of clothing, such as shirts and sweaters.

81

TIPS FOR DRAWING CLOTHES

I recommend drawing from life. Find a crowded place where you won't feel self-conscious, like a train station, a town square, or the mall. Look for a locale where people stand still—for a little while at least—and do some quick sketches. These may not be pretty, but when you return home, you'll have a reference from which to work.

To draw the items in my own closet, I simply placed each piece on a hanger, and put it somewhere visible but out of the way within my home. This allowed me to take my time while drawing.

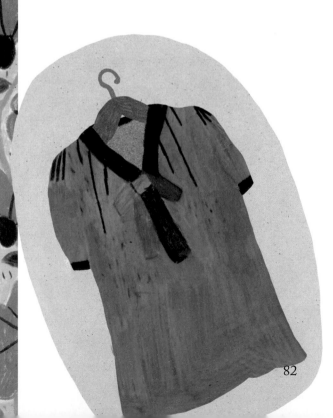

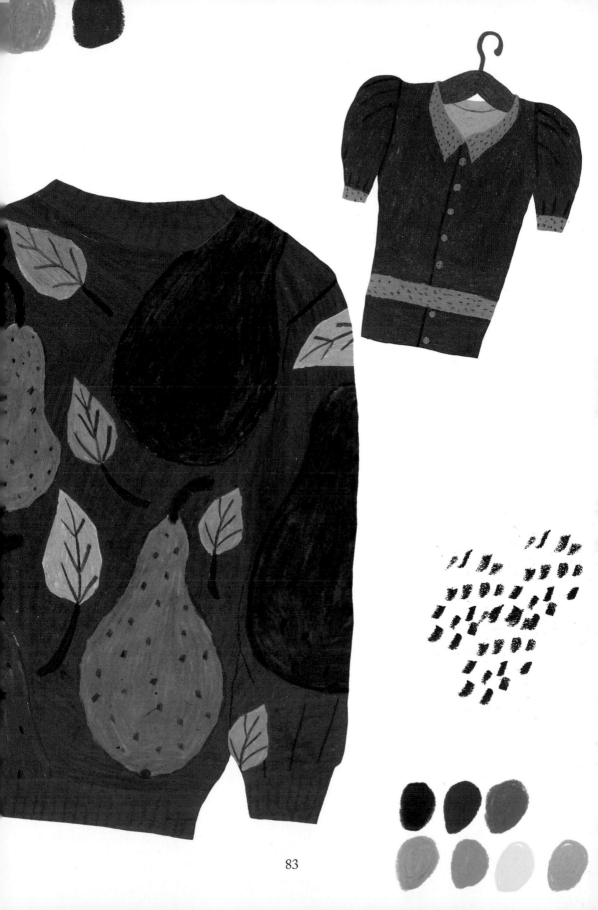

HAPPY HOMES

Every house is more than just brick and mortar or wood—it tells the story of past and present occupiers. When I walk home through London at night, I look up at the houses I pass and imagine the stories that define each one. It's fascinating!

Where I live, there are Victorian terraced homes, ancient churches, and blocks of flats from different decades. It is a wonderful mish-mash of modern and old—full of shapes and lines and colors. When I visit my dad in Sweden, I cannot help but draw the houses there with their double-angled rooflines.

There is endless creative inspiration to be found in architecture, from the patterns of roof tiles and bricks to the shapes of a structure's windows. Wherever you live, go out and draw the homes in your neighborhood. What stories do they tell? What are their quirks and idiosyncrasies?

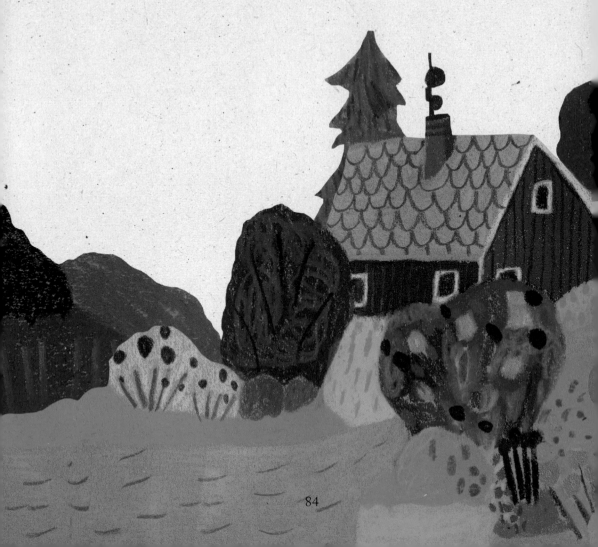

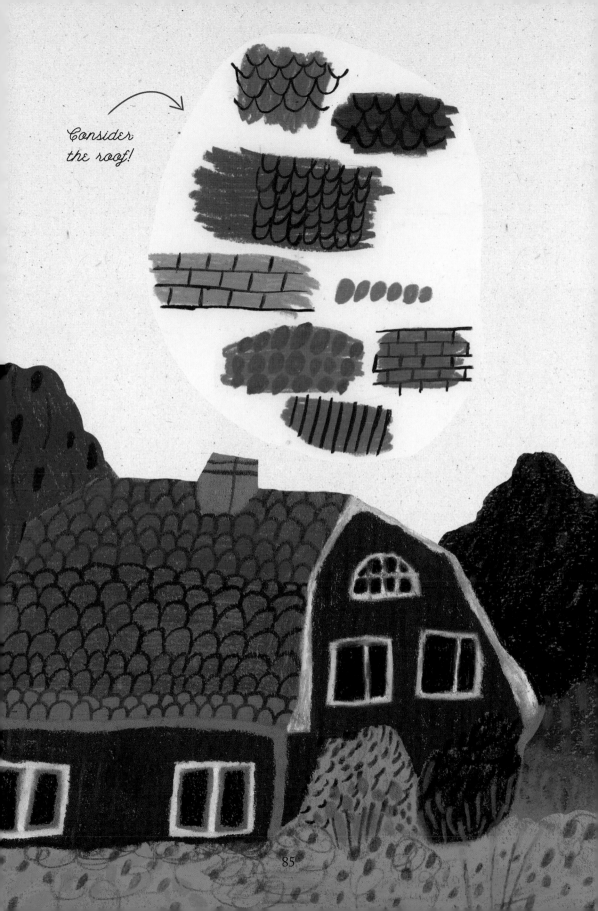

Consider the roof!

DRAWING A HOUSE STEP-BY-STEP

This is a little cottage located in the English countryside. I don't know who lives here, but I have written a story in my head of the lives of the people inside this house. I can't help it! I guess artists are storytellers in a way.

STEP 1

Draw the shapes of the brick wall and the house. I chose two stone-colored crayons and lightly filled in the shapes of the building.

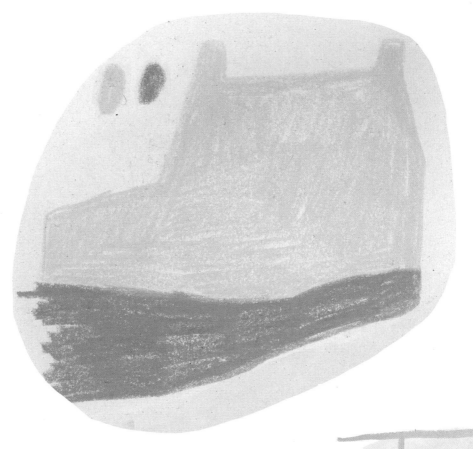

TIP

Experiment with bright as well as muted colors, and see how they make your eyes travel around a picture in different ways.

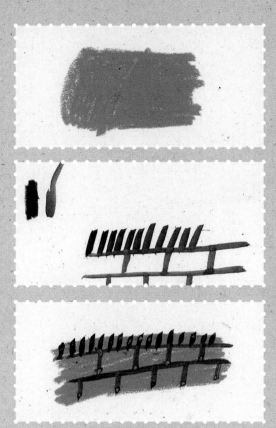

STEP 2

Next, with a dark green crayon, draw branches to suggest a tree in the foreground. Then draw lines to create a stone wall. Over that, using a watercolor brush dipped in water, transfer some color from a water-soluble crayon. Paint fine lines into a brick-wall pattern.

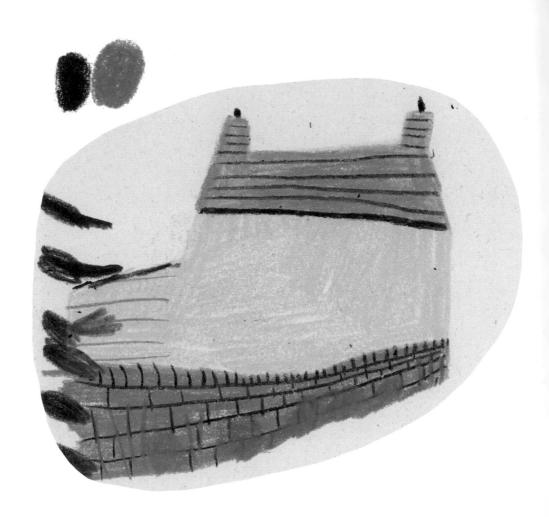

STEP 3

Add lines to create a tiled roof and shed on the side of the house. Using a muted green, suggest plants growing in front of the wall.

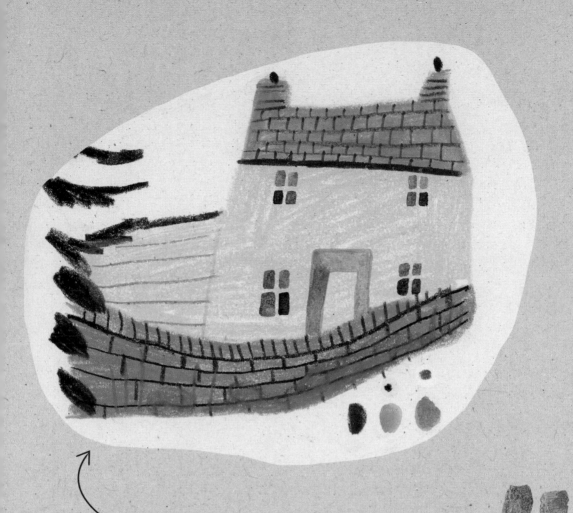

STEP 4

Draw the roof tiles. Because I've drawn this house on a small sheet of paper, the details of the windows are too tricky to create with my sometimes-clumsy crayons. Instead, I used a brush and some water to paint the windows and the doorframe.

STEP 5

Using a purple crayon and some water, "paint" the door, the windowframes, and the flowers in front of the stone wall.

Then sketch just a hint of wobbly, oblong bushes around the house. Transfer some green color from a water-soluble crayon with a watercolor pencil dipped in water. When that has dried, add leaf texture using different colors of green. Fill in with a pink crayon. Then paint lightly over it, using a brush, water, and a green crayon.

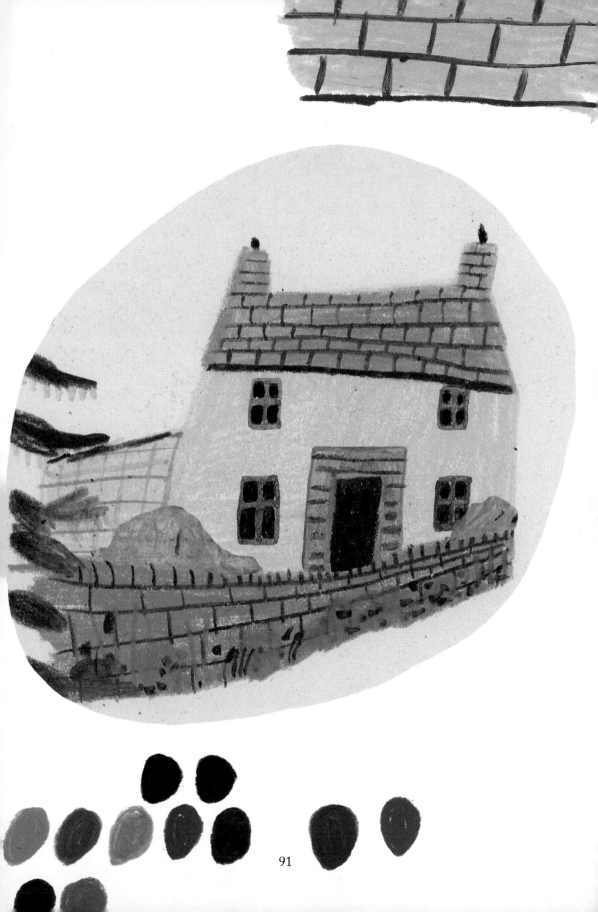

PEDALS & PETALS

One of my earliest memories is of being teased by some of the slightly older neighborhood children for still cycling around on a tricycle while they zoomed around on bicycles *without training wheels*. When my brother finally grew too big for his bicycle and got a new one, I was given his old one. It was a golden-green bike, and soon I zoomed around on it.

I've loved bikes ever since, and with their simple lines and bright colors, they're also fun and easy to draw. Do you have a bike? Draw it! If you don't own a bike, you will find lots of photos online that you can mix and match and use as drawing inspiration.

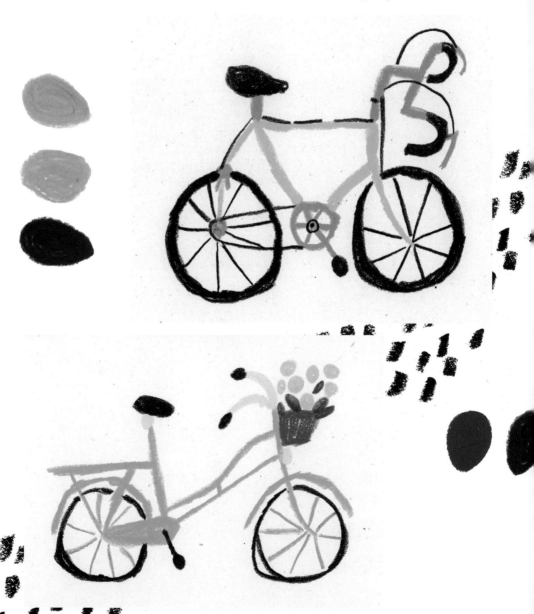

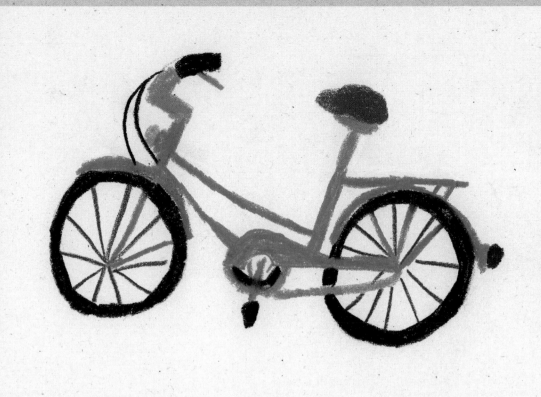

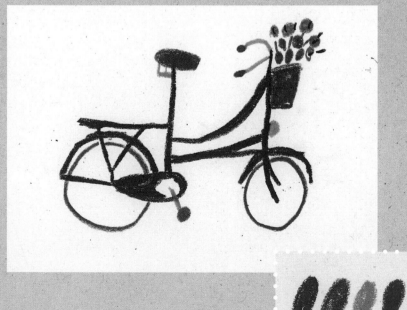

DRAWING A BICYCLE STEP-BY-STEP

If drawing a bicycle intimidates you, remember that it doesn't have to be perfect!

STEP 1

I used a red crayon to draw my bicycle. Any color will do, though!

First, draw a "V" shape with a line horizontally across the top for the bike frame. Then draw the chain guard as a sideways teardrop shape. Leaving an oblong space on the fat side without color, fill in the rest of the teardrop. Draw a diagonal line up from the middle of the chain guard, connecting it with the horizontal line.

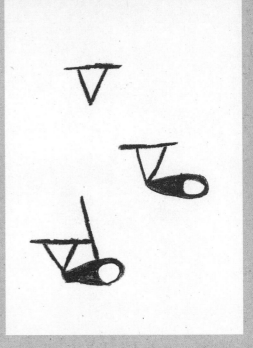

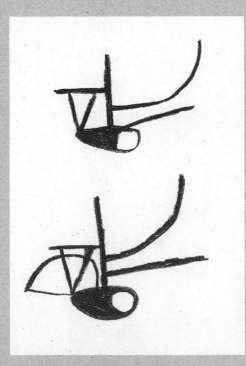

STEP 2

Draw a curved line from the chain guard. Then draw another line out from the chain guard. Draw a half-circle for the back wheel.

STEP 3

Draw another half-circle at the front of the bike. Draw a "J" shape to connect the handlebars with the wheel pole.

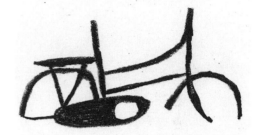

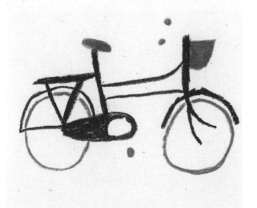

STEP 4

Using a brown or black crayon, create two circles for the wheels. Then add the bike's seat, which looks a little bit like a squashed bean. Draw two dots for the grips of the handlebars, a basket (like a flattened, filled-in "U" shape), and a dot for the pedal.

STEP 5

Grab a gray crayon, and add the handlebars, the seat's attachment, the front light, and the kickstand.

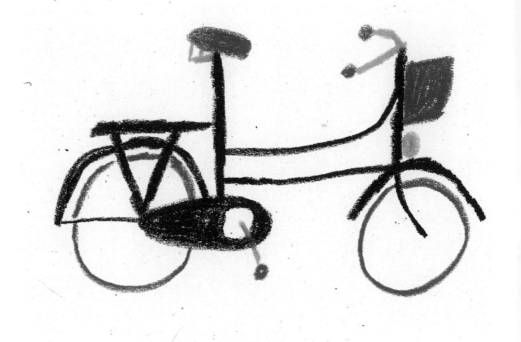

Now who's ready for a ride?

STEP 6

Add flowers in the basket to finish your bicycle drawing.

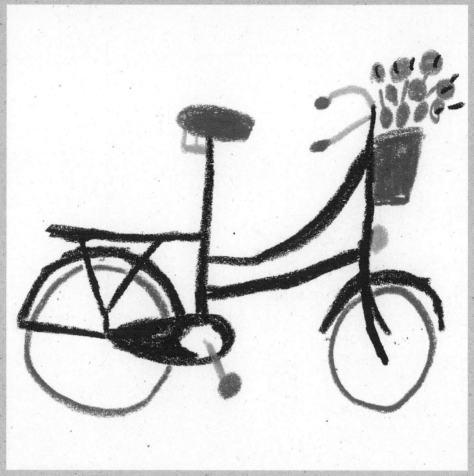

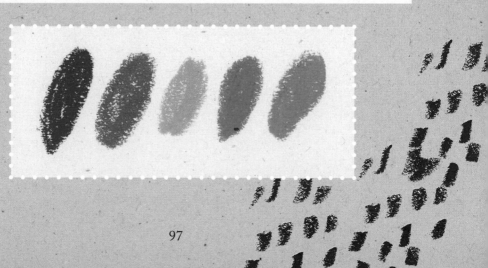

GORGEOUS GARDENS

Gardens change with the seasons. I am lucky to live close to a large, ancient park in London, which I like to think of as my family's garden. During the late summer, we pick blackberries there, and in springtime, we watch as the park transforms from gray to full of colors. While the kids play soccer, I collect flowers and leaves in a sketchbook to draw later.

Do you like to draw flowers, trees, wild animals, or all of the above? Here's how to draw some of the elements in a typical garden. Once you've perfected creating flowers and grass, try creating your own garden. What would you add? Which colors would you use?

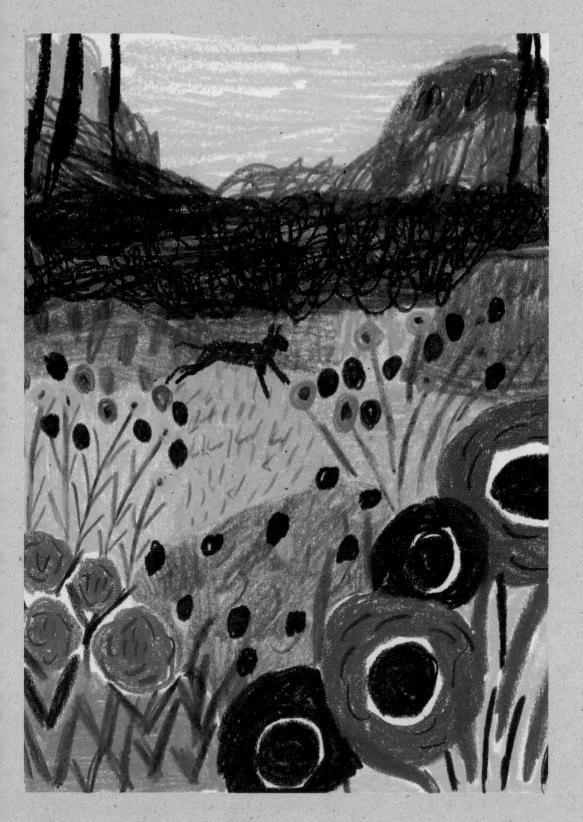

DRAWING A GARDEN STEP-BY-STEP

Drawing a garden is a bit tricky. It can be a sea of green, or it might be so busy with flowers and leaves that it's hard to know what to draw without choosing a focal point.

I find it's easier to get started if I compartmentalize a garden into little sections by noticing how one green bush differs from another in shade, texture, and size.

For this step-by-step exercise, I drew several little scenes to help you learn to create a garden. Practice drawing leaves, copying their shapes, and mixing colors to get the right blends.

WINTER'S GARDEN

STEP 1

Start with a green blob.

STEP 2

With a purple crayon, draw a "V" shape and then another, skinnier "V" inside to create a plant's shape. Repeat these shapes all over the green blob. Make sure the plants don't sit in a straight line and that they're slightly asymmetrical to add interest to your garden. Also add dots all over the garden.

100

BEAUTIFUL BOUQUET

STEP 1

Draw the outline of a bouquet of flowers using a light blue crayon. Try drawing an upside-down trapezoid with asymmetrically positioned circles on top. Then add four stalks using olive-green.

STEP 2

Draw four flowers where the circles are. I used a turquoise crayon, and then I drew petals with a darker blue crayon. To finish, use a lighter green to draw leaves on the stems.

SUMMER'S FLOWERS

STEP 1

Draw a bright green blob, and add "V" shapes over it.

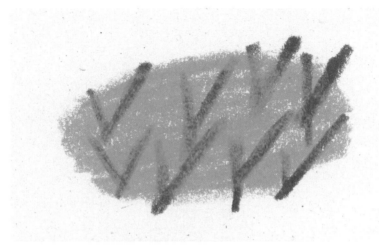

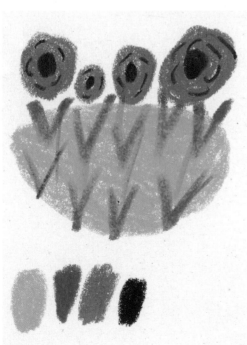

STEP 2

Draw pink circles, and add details on top using a red crayon.

A VISIT TO THE PARK

Now that you know how to draw some of the elements in a garden, you can create your own eclectic park. Doesn't this one look like a lovely place to play with your dog?

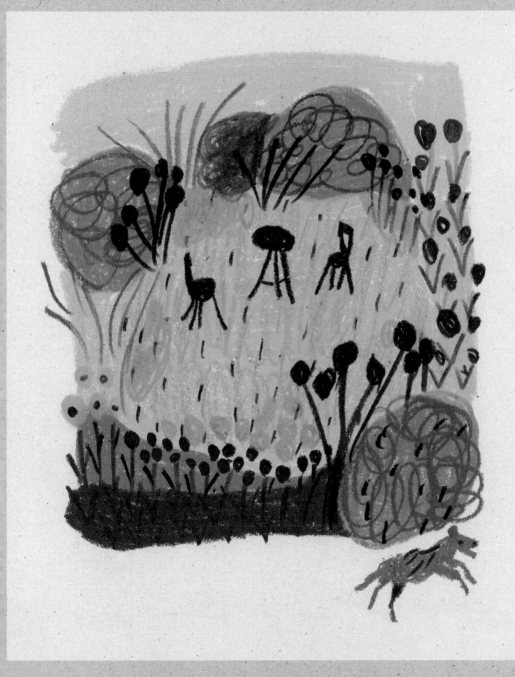

Combine the elements you just learned to draw into one gorgeous garden!

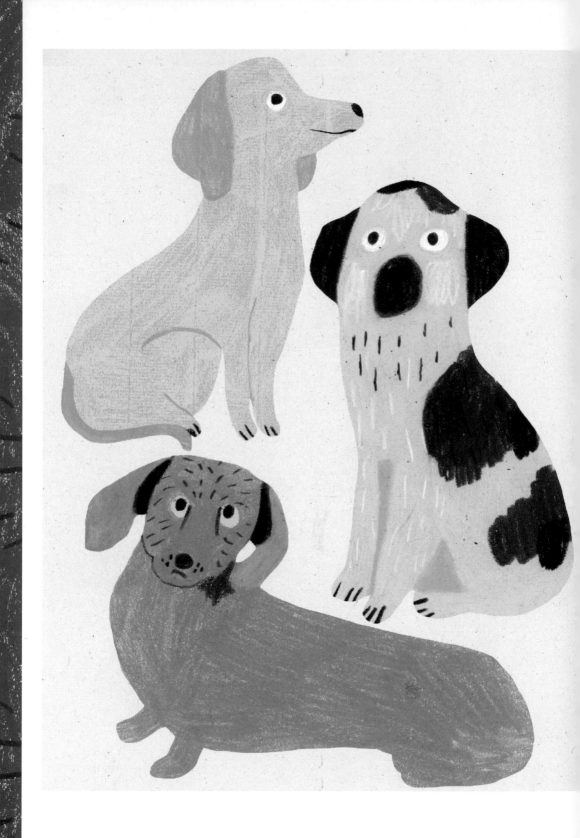

SILLY PETS

As a child, I wanted a dog so badly. Failing that, I would have been happy to settle for a horse. (I must add that I'd never ridden a horse, and I didn't even really like horses, but I was really into reading about horses.)

When my son, who was about 4 years old at the time, asked if we could get a cat, I remembered my own longing for a dog, and said, "Yes, of course."

Cats and dogs make equally accessible subjects for drawing, although their movements can make them difficult to draw. The nice thing about drawing animals using crayons is that their colors don't need to be true to life—use any combination and patterns that you like!

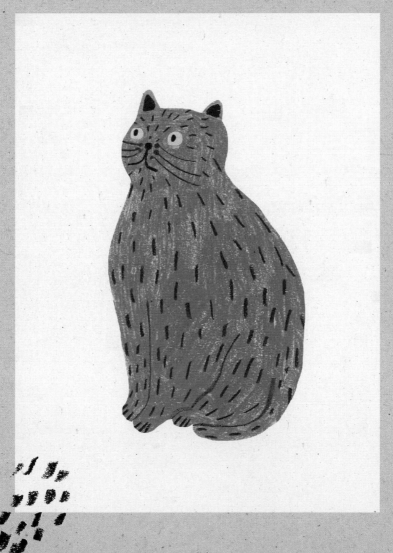

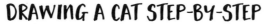

DRAWING A CAT STEP-BY-STEP

When our youngest son was a baby, our block of flats was taken over by mice, and nearly everyone who lives here got a cat. We got our cat, Eddie, from an animal shelter.

I draw him a lot; it's easy to do so because he spends his days sleeping while I'm working. Eddie doesn't have a tail, he gets into fights, and he's a master mouse catcher. He's snoring loudly as I write this ... and draw him!

Here's how to draw this cat's head.

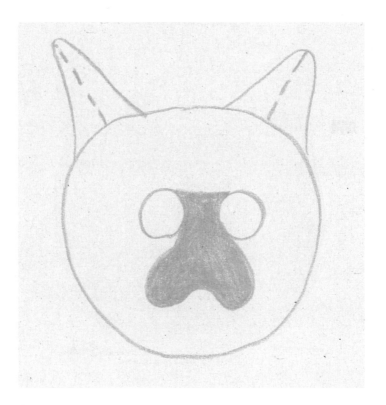

STEP 1

Draw a circle for the cat's head using yellow-orange. Add the ears, eyes, and an upside-down heart shape for the cat's mouth and nose. Color in the nose area, and add lines to the ears.

STEP 2

Color in the ears with yellow-orange and pink, and add a darker red-orange color for the rest of the face. Add lines on the ears and turquoise eyes.

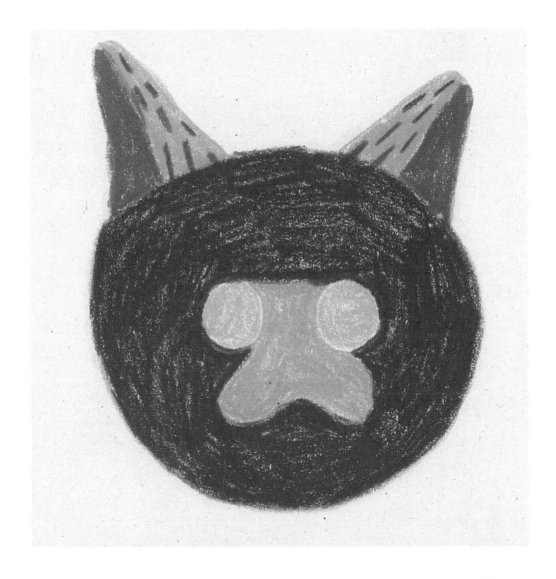

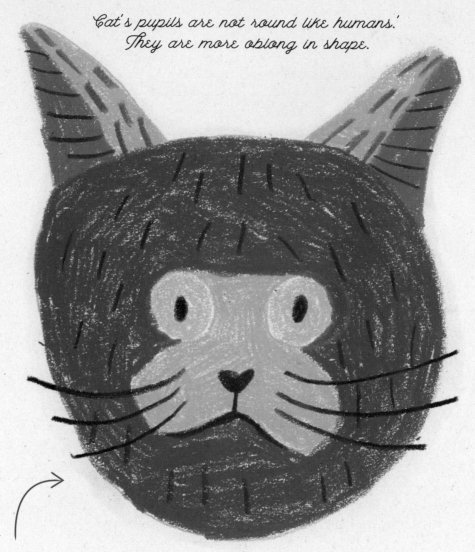

STEP 3

A cat's nose looks a bit like a heart with a line down to the mouth. I drew this using a wine-colored crayon. Add texture to the cat's face using the same crayon, and use purple for the cat's whiskers and pupils.

GET CREATIVE WITH CATS

Sketching animals makes for really good practice.
Look at their shapes, observe how they move, and
experiment with drawing fur.

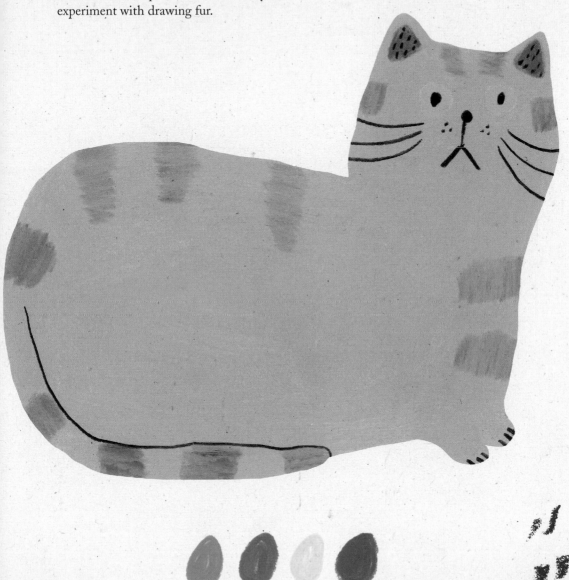

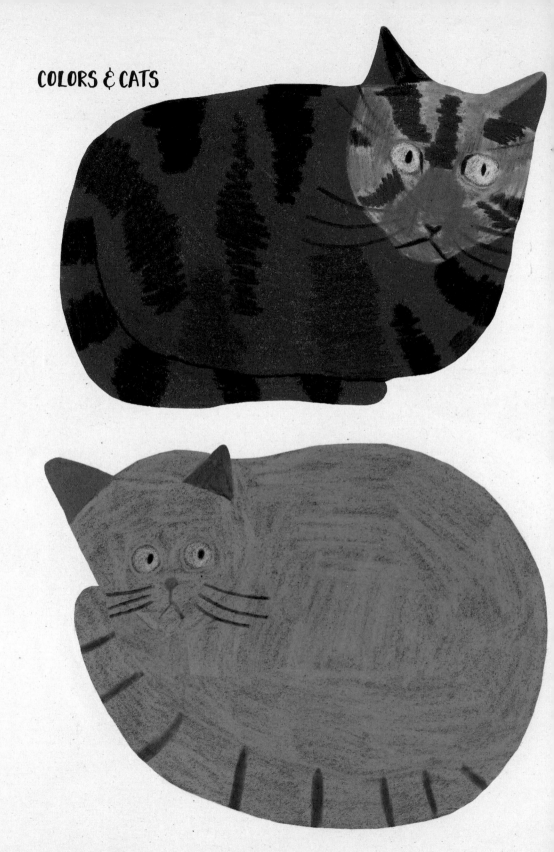

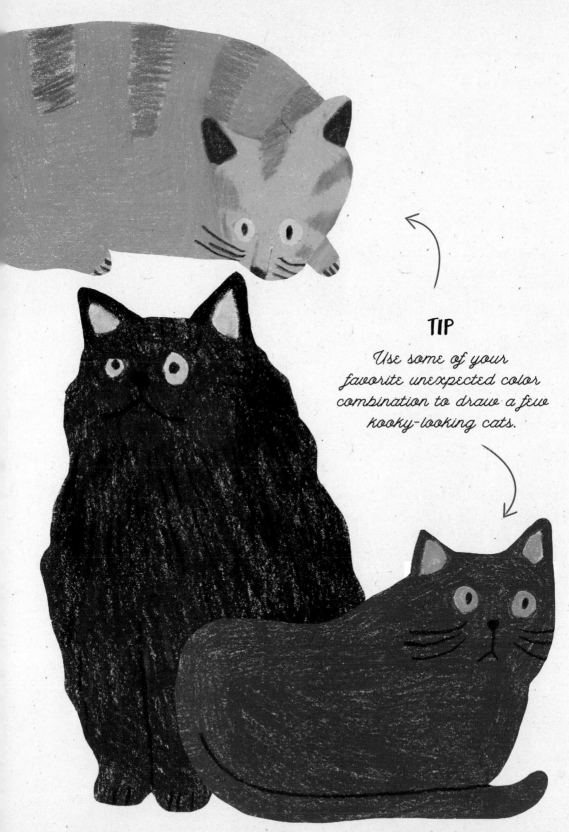

TIP

Use some of your favorite unexpected color combination to draw a few kooky-looking cats.

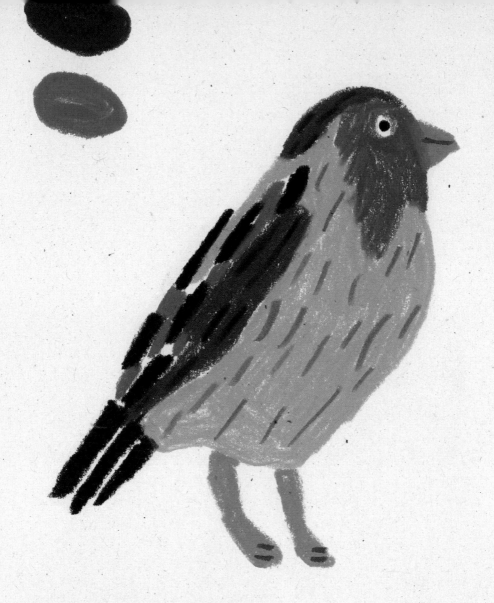

BEAUTIFUL BIRDS

I love birds! I used to have a pink plastic flamingo ornament in my family's garden, and it was great for practicing drawing flamingos, as there aren't many real ones where I live. Sometimes I watch nature programs and make quick sketches of the birds I see. To do this, keep your eyes firmly on the TV screen, and quickly draw what you see. You will surprise yourself by catching the essence of a bird rather than a photorealistic representation.

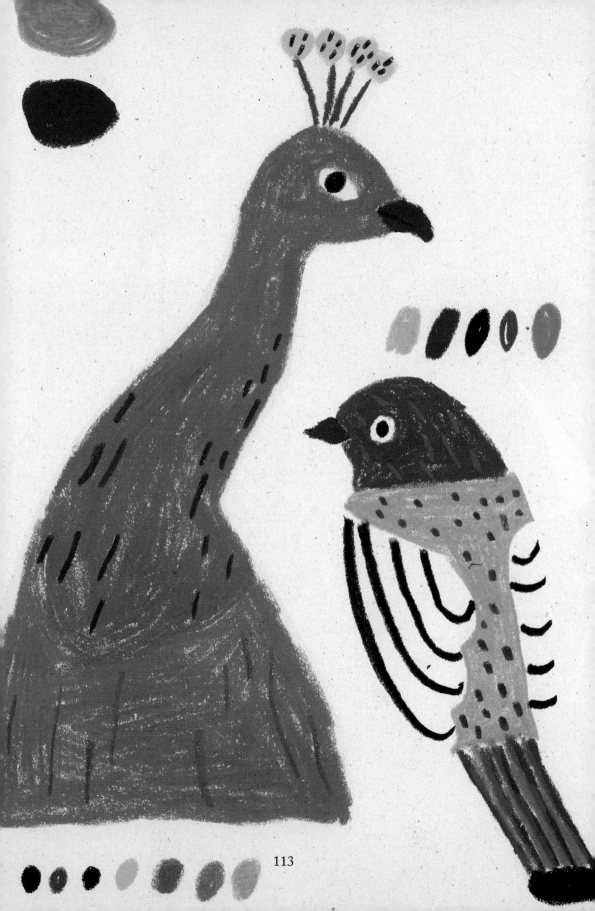

113

DRAWING A BIRD STEP-BY-STEP

Simplified birds consist of basic shapes and are easy and fun to draw.

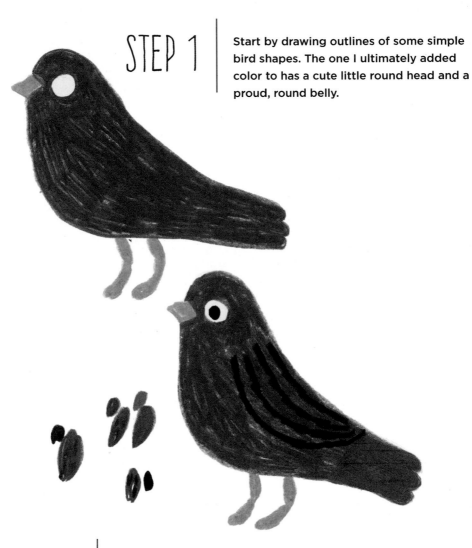

STEP 1

Start by drawing outlines of some simple bird shapes. The one I ultimately added color to has a cute little round head and a proud, round belly.

STEP 2

Color in the bird (I used light brown), and add a beak and some little legs. I chose a vivid yellow-orange to give the bird some brightness and lightness. I also drew gray dots all over the bird's body using the same color that I applied to the tail. I added dark brown stripes for the wings and dots for the eyes.

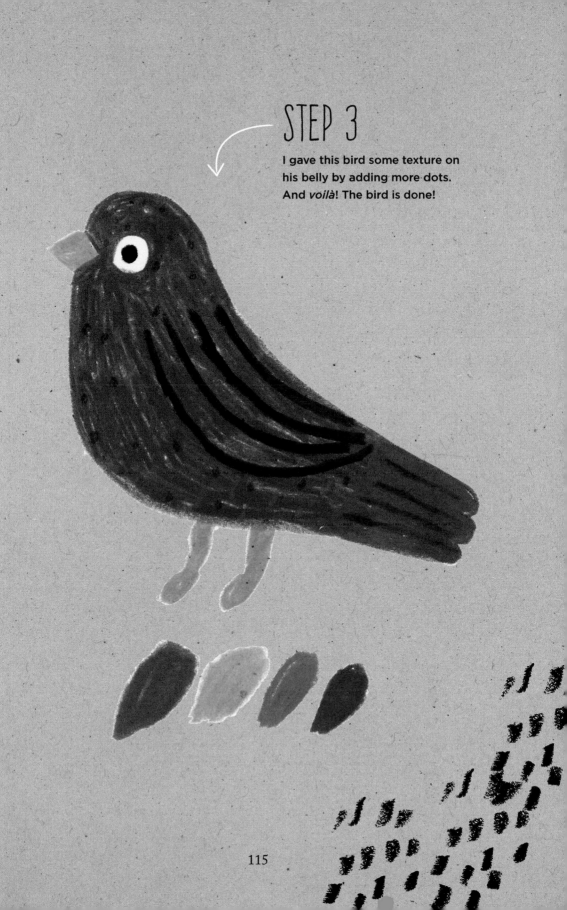

STEP 3

I gave this bird some texture on his belly by adding more dots. And *voilà*! The bird is done!

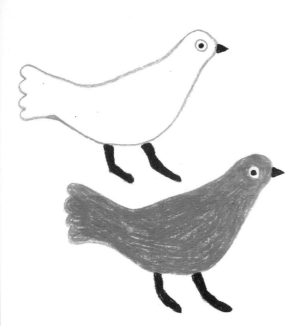

COLOR CHOICES

What would happen if you gave the bird a bright red beak and legs? Or colored the feathers a vivid pink or a duller orange?

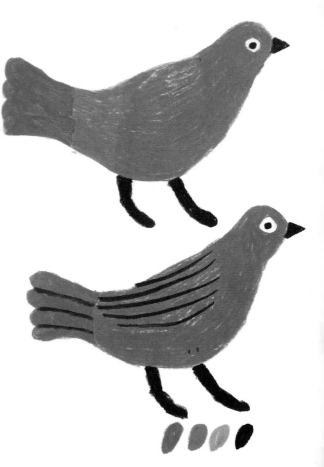

Although I started out drawing a bright pink bird, I felt that it looked a little dull. I added orange over the pink, leaving out the wings and the tail. This color scheme felt a lot richer and more vivid to me.

BIRDS

BIRD

BIRDS

How would you color in the birds drawn here?

I have a postcard of parakeets that I used as inspiration for this drawing. I decided to try and draw one of them in the form of a tropical bird. I quickly copied the shape of one of the birds in a line drawing. Then, instead of working on the bird, I used the negative, or outline, of its shape and colored in the background. I drew some leaves too. When this was done, I added minimal details to the bird itself, letting the paper serve as its base color. I only colored in the beak, eyes, and a hint of feathers. Finally, I made the head feathers yellow.

TIP

*Once you've mastered drawing bird shapes,
you can go wild and make up all kinds of
patterns and use lots of bright colors.*

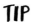

These two birds have very simple shapes,
but I jazzed them up by adding lots
of lines, dots, and bright colors. I
sketched them out in a light-colored
crayon and then divided each bird
into different sections. That is, I drew
the shape of the wings, the chest, and
then the head and the tail. I colored
one section in at a time. I picked
colors totally at random, without
allowing myself to plan or
think too much; instead, I
allowed myself to have
fun. And here they
are: two wild
and crazy
birds!

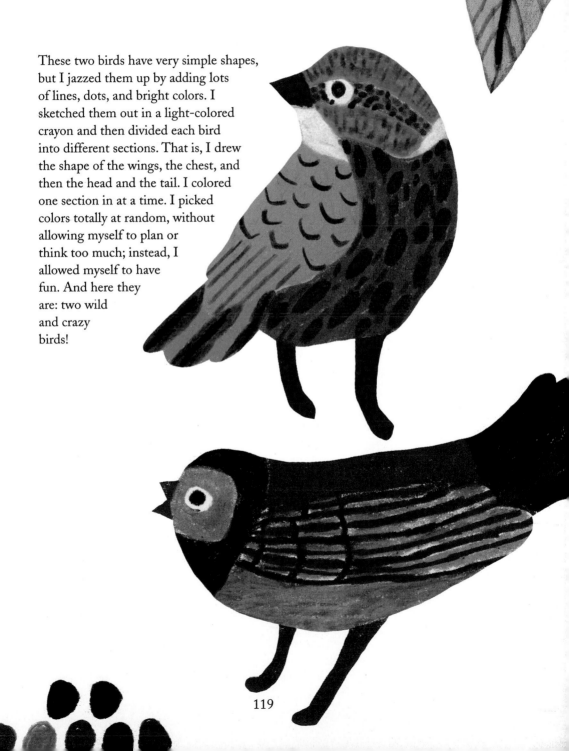

119

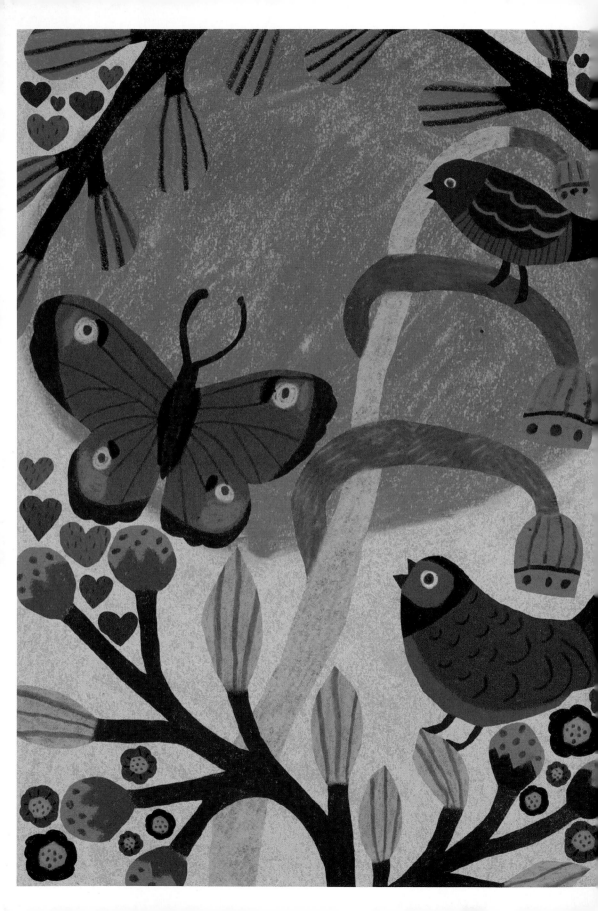

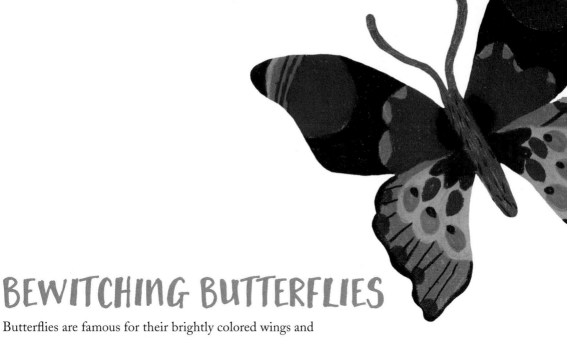

BEWITCHING BUTTERFLIES

Butterflies are famous for their brightly colored wings and conspicuous, fluttering flight. In fact, they're so colorful that you're probably going to need some more crayons to draw them!

Have you ever tried to catch one? One summer when I was a kid, my friend and I would run after butterflies, trying to catch them. At the end of that summer, I found a mourning cloak butterfly in a barrel full of water in my friend's garden. I scooped it up and it lay completely still in my hand. While studying it closely, we became very sad and made a plan to bury it.

Then suddenly, I felt it start to move. Its features were kind of monstrous when looking at it up-close, so I got scared and set it on the grass. When its wings dried, the butterfly flew away, and my friend and I ran off to play again.

Butterflies are amazing and so much fun to draw with crayons.

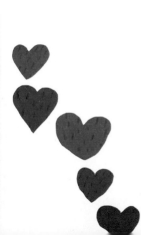

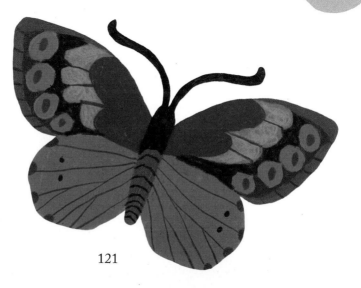

BUTTERFLY BRAINSTORMS

Practice drawing different kinds of butterfly wings. Some butterflies have softly rounded wings, while others have more dramatic shapes.

If you want exact symmetry, fold a sheet of paper in half, and cut out the shapes of one wing, half a body, and an antenna. When you unfold the paper, you'll have the perfect outline of a butterfly. You can also sketch it out if exact symmetry isn't important to you. Practice until you find a butterfly shape you like.

Then add color. Draw a pattern, or copy a real butterfly's wings. Do whatever you want!

TIP

Bring back that inner child in you who had no fear of making mistakes.

DRAWING A BUTTERFLY STEP-BY-STEP

This drawing uses cool colors (see page 22) to create a vivid, eye-catching butterfly.

STEP 1

Start by drawing the shape of a butterfly's body with a rich red-brown crayon. The body of a butterfly is shaped a bit like a cigar. Then draw the antennae with a darker brown crayon. For a textured look, add lines all over the body. Smudge and blend until you're satisfied.

STEP 2

Now draw the shapes of the butterfly's wings, and color them in. I picked lavender-blue as my wing color. The butterfly doesn't have to be realistic, so let's add some unusual colors and patterns in the next step.

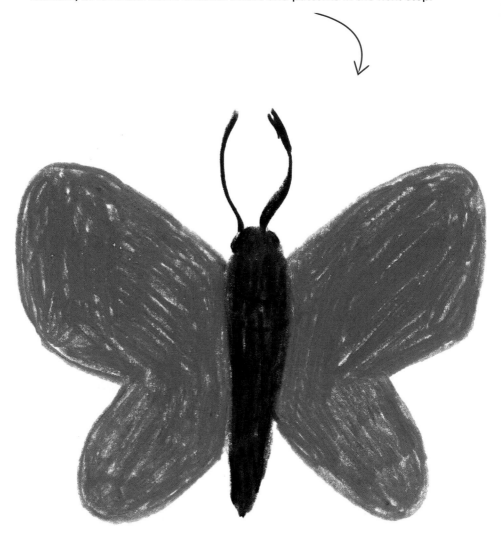

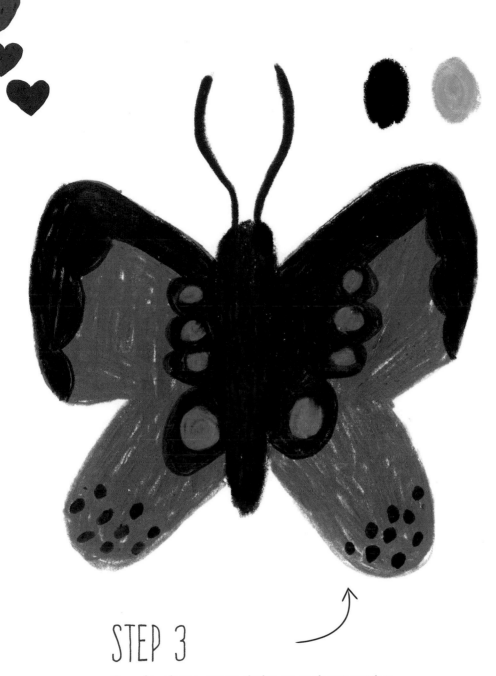

STEP 3

Draw four large, green circles on each upper wing.
Using dark blue, draw the dark shapes of the
upper wings, and add dots to the lower wings.

125

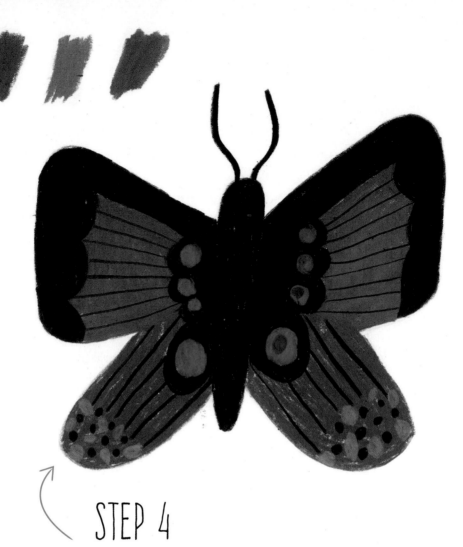

STEP 4

Add more details to the butterfly in a pattern that you like. You can also create depth by blending the remaining lilac-only areas with pink on top.

Then use a red-brown crayon over some of the dark blue to create a bit of texture. Lightly fill in the upper wings with pink. Then draw lines with a lavender-blue crayon. Draw lines on the lower wings in dark brown. And that's it!

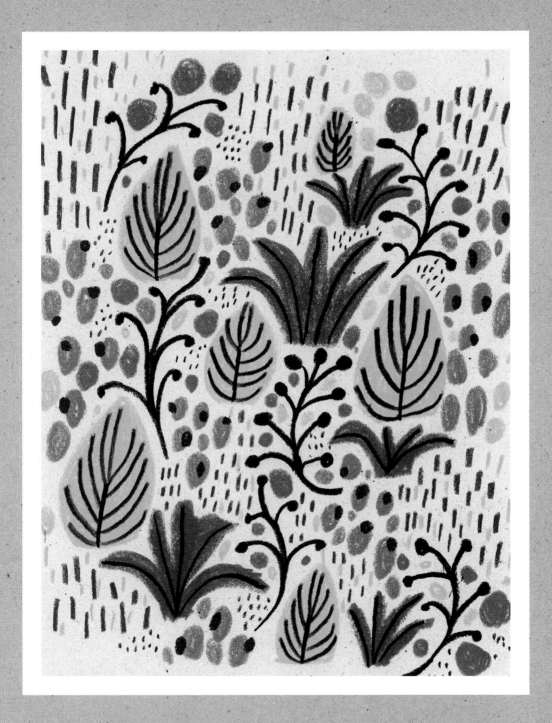

ANYWHERE ART

Now that you've learned the techniques for drawing with crayons anywhere and at any time, I hope you'll practice as often as you can! Use your imagination to come up with lots of new subjects and color combinations, and most of all, have fun!

ABOUT THE AUTHOR

Monika Forsberg was born in the far north of Sweden and moved to the United Kingdom in 1995 to study animation. She graduated from the Royal College of Art in 2001, and that same week, she gave birth to her first child.

Monika worked as an animator until the birth of her second child, when she decided to indulge in her love of colors, patterns, and drawing and become an illustrator.

Monika currently lives in London, where she creates her magical, vividly colored fantasies. She gathers inspiration from the higgledy-piggledy streets of north London, conversations with her children, and memories of her childhood in the land of snow and midnight sun.

"My mum and I would wander around fabric shops in my hometown, and she taught me a lot about how colors and patterns work. She favored using two different shades of blue together with a contrasting pink or purple. Those were her colors and still, when I see purple and blues together, I think of my mum. Memories are important to me."—Monika Forsberg

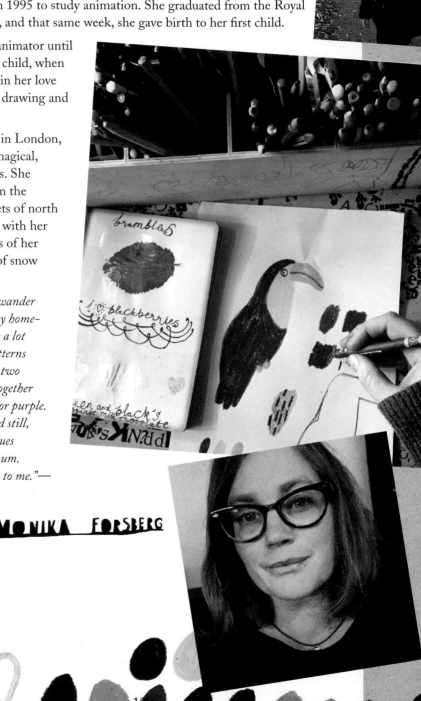

MONIKA FORSBERG